Pasolini
in Chiaroscuro

Front cover: Angelo Novi, *Pier Paolo Pasolini on the Set of* Theorem, 1968, silver photography, Cineteca di Bologna / Fondo Angelo Novi
Back cover and flaps: *La Ricotta* (details), 1968

Guillaume de Sardes

Pasolini in Chiaroscuro

Bartolomeo Pietromarchi

 Flammarion

The Nouveau Musée National de Monaco, in keeping with its cross-disciplinary approach to creation, has often hosted exhibitions from the world of cinema in its Paloma and Sauber villas: Jean Cocteau and Christian Bérard recently, or Francesco Vezzoli in 2016 with *Villa Marlene*, an exhibition dedicated to the iconic Marlene Dietrich.

Film is once again to be showcased within the museum walls, this time those of director Pier Paolo Pasolini, the centenary of whose birth was celebrated only two years ago.

The *Pasolini in Chiaroscuro* exhibition demonstrates his discerning knowledge of the history of painting and his films bear the traces of this knowledge; scenes, compositions, framing, angles, backgrounds, lighting and sets —his entire body of work is permeated with an intense pictorial culture. In a form of mise en abyme, the museum has become a space in which this demonstration can take place.

References to works both classic and modern are interspersed throughout his films, and the exhibition extends this interplay of echo and comparison by bringing together works from contemporary artists for whom Pasolini continues to be a source of inspiration. Pasolini's legacy is still alive and well.

The Princess of Hanover

As a poet, novelist, filmmaker and polemicist, Pier Paolo Pasolini was a man of many facets. Is this why, some fifty years after his murder, his place as a major figure of his generation is so firmly established? Few deceased artists are still so admired, quoted and commented on; even fewer remain so relevant to our contemporary world. Indeed, to evoke Pasolini is to consider the artists of today.

And this is clearly visible in the exhibition, *Pasolini in Chiaroscuro*, presented at the Villa Sauber, where the term "chiaroscuro" relates as much to paintings by Caravaggio as to the black-and-white film *Accattone*. The first part of the exhibition focuses on the aesthetic influence of his predecessors on his writing and filmmaking, while the second illustrates, in a parallel fashion, how he in turn has influenced his successors. Some thirty artists are presented here, of all ages and nationalities, reflecting the choices made by Guillaume de Sardes from among a great number.

Just as Pasolini was inspired by classical painters in the composition of his film shots, which in turn became the starting point for new works, the exhibition *Pasolini in Chiaroscuro* was inspired by those held in 2022 for the centenary of the birth of this writer and photographer. In particular, the exhibition has benefited greatly from the work carried out by the Cineteca Bologna. Many thanks go to its director Gian Luca Farinelli.

Bjorn Dahlström
Director of the Nouveau Musée National de Monaco

Pages 8–9: Angelo Novi, *Pier Paolo Pasolini on the Set of* Theorem, 1968, silver photography, Cineteca di Bologna / Fondo Angelo Novi

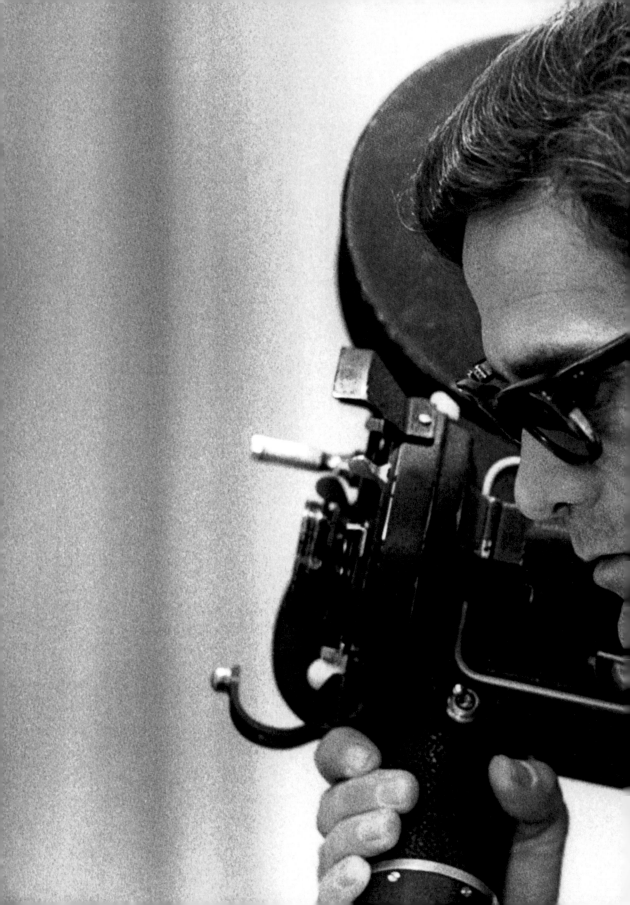

Pasolini in Chiaroscuro

Guillaume de Sardes

"Every angel is terrifying."
Rainer Maria Rilke

When Pier Paolo Pasolini was murdered in 1975 on scrubland near the beach in Ostia, he was world-famous. His latest films had been a critical and commercial success. In Stockholm, the Swedish translation of *Gramsci's Ashes* had just been published, the first step toward a potential Nobel prize. His violent death, marking the end of an oeuvre haunted through and through by beauty, sex, and tragedy, turned his life into fate. While Hervé Joubert-Laurencin isn't wrong to warn us against the retrospective illusion of seeing Pasolini's life in light of his death, it is also true that, as the young French philosopher Guy Hocquenghem put it, "Pasolini wouldn't have died if he hadn't slept with his actors." Hocquenghem's provocative phrase recalls Pasolini's taste for cruising and "rough trade," a penchant that was not without risk, the very danger constituting a part of the pleasure. Whatever the reasons for Pasolini's murder (political assassination or sexual encounter gone wrong), his death was in keeping with his free, dissident life, his dangerous mode of existence.

Pasolini made no secret of his preference for bad boys, including the ones you pay. In his autobiographical poem "Poet of Ashes" (1966), he describes meeting "two or three soldiers, in a thicket of whores." Though Pasolini didn't wish for his wretched death, he headed toward it by refusing to look for love in the circle of his own peers. The philosopher René Schérer, in a beautiful book, found fit words to describe this death: "It does not contradict the permanent risk of the exposed life that it seals and allegorizes, as it were. [...] In the manner of the death of Saint Paul, killed for his words and acts." Didn't Pasolini himself, in his essay on cinema *Heretical Empiricism*, tell us that "death effects an instantaneous montage of our lives"?

While Pasolini's oeuvre was indeed interrupted, it has such great coherence and clarity of message that it does not give the impression of being incomplete. One can distinguish two periods within his work: the first devoted to literature and the second to cinema, with 1960 and the making of *Accattone* as the turning point. At the age of thirty-eight, Pasolini moved away from poetry to dedicate himself to film. The second period, during which he made one film after another, would last fifteen years, up to his death. These "film years," however, did not constitute a complete abandonment of literature, since he published some of his scripts as books and devoted a portion of his last years to writing *Petrolio*, a vast experimental novel which, though unfinished, is arguably his greatest work of all.

Though Pasolini liked to define himself principally as a writer, it was through his films that he reached a mass audience. And this audience, by offering a sounding board for his political ideas, is what did the most to turn him into a world-famous European intellectual—perhaps the last of our time. It is true that the context in which he worked—that of an artistically and commercially triumphant period of Italian cinema—was particularly favorable; but Pasolini's fame is due above all to the peculiar, troubling beauty of his work. A half-century after his death, his influence still echoes throughout the various fields he mastered: he is read, quoted, analyzed, adapted; he inspires the artists of today.

 It is the filmmaker Pasolini, seen through the lens of classical and contemporary art's influence on the aesthetic of his films, that I have attempted to approach here, in the wake of the beautiful exhibition *Pier Paolo Pasolini, Folgorazioni figurative* (Pier Paolo Pasolini, Figurative Flashes) staged in 2022 at the Cineteca di Bologna.

 Pasolini's university years were central to his work. His studies at the University of Bologna, under the direction of the art historian Roberto Longhi, trained his eye and permanently influenced his taste. It is revelatory, in this regard, to place certain of his film-shots side by side with classical paintings. Pasolini reappropriated the masterpieces of Italian art in three ways: by evoking them through a play of resemblances and striking details; by identically recreating them as tableaux vivants; and by including the artworks themselves in the film sets.

The artists who inspired Pasolini were mainly the classical painters of the thirteenth, fourteenth, fifteenth, and sixteenth centuries, with one notable exception: Francis Bacon, whose paintings appear in various forms in *Theorem*. The "case" of Bacon exemplifies Pasolini's ambivalence toward the art of his time. Pasolini's mistrust of the latest contemporary art was genuine, but it did not keep him from maintaining a friendship with the artist Fabio Mauri, and even participating in one of Mauri's performances.

Pasolini's nostalgia for pre-industrial Italy did not sever him from the present. He looked upon the rise of consumerist society with painful clarity. It inspired him to make his final film, the most political of all, *Salò, or the 120 Days of Sodom*. The radicalism of *Salò* is so extreme, it goes beyond cinema and verges upon contemporary art. More than a filmmaker, Pasolini was an experimenter, a creator of new forms—this undoubtedly explains why so many artists have paid homage to him, and continue to do so.

A Filmmaker in the School of Roberto Longhi

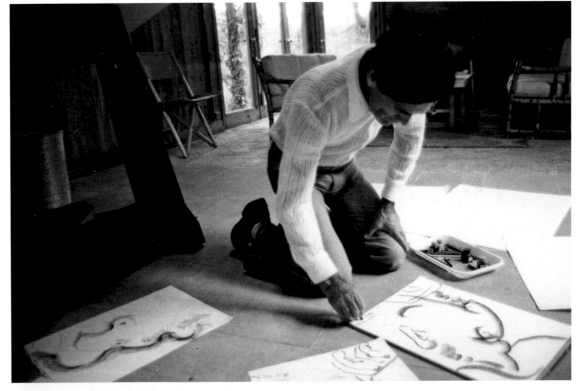

Dino Pedriali, *Pier Paolo Pasolini in Chia*, 1975, silver photography, Archivio Dino Pedriali / Fondazione Cineteca di Bologna

I. The apprentice years

Bologna, "a city full of arcades," was the site of Pasolini's intellectual education. He went to high school at the Liceo Galvani before enrolling at the university's faculty of letters one year early: he was seventeen. His teachers were the young poet Alfonso Gatto and, above all, the art historian Roberto Longhi. During the 1941–1942 academic year, on via Zamboni, Pasolini attended Longhi's class on Masolino and Masaccio, a course that would later be published as a book and become a classic. With the help of a slide projector, the great art historian showed his students which parts of a joint fresco were painted by Masolino, and which parts by Masaccio. In doing so, he gave them the greatest gift of all: the gift of seeing.

Just after Longhi's death on June 3, 1970, Pasolini wrote a brief text that for a long while remained unpublished. In it he portrays Longhi as a teacher. But "What is a teacher?" he asks. "A teacher is generally only understood as such in retrospect: the meaning of the word thus resides in memory, as an intellectual (not always rational) reconstruction of lived reality. In the moment that a teacher is actually, existentially a teacher—that is, before being construed and remembered as such—he is thus not really a teacher, in the true sense of the word." Lonhgi's personality nevertheless stood out sharply from the other professors at the University of Bologna: "He spoke as no one else spoke. His lexicon was a complete novelty. His irony was without precedent. His curiosity had no model. His eloquence had no agenda. For a student oppressed and humiliated by scholastic culture—by the conformism of Fascist culture—this was revolutionary."

Longhi revealed to Pasolini what culture is, in so far as it profoundly differs from scholastic culture. He also decisively oriented Pasolini's approach to painting by introducing him to the painters of the Middle Ages and the Italian Renaissance, and also, a few years later, to Caravaggio. (Longhi curated a large Caravaggio exhibition at the Royal Palace of Milan, April–June, 1951, which sparked a revival of studies on the painter and his followers. Longhi published in its wake a monograph that Pasolini certainly read.)

In an article heralding the publication of an anthology of Longhi's writings, Pasolini clearly indicated the preeminent place he accorded Longhi in Italian culture: "In a civilized nation," wrote Pasolini, "this should be the cultural event of the year"(*Il Tempo*, January 18, 1974). During the same period, in a passage of *Petrolio* that inventories the contents of a suitcase full of books—"a real, very coherent little library"—after having listed Dostoyevsky's *The Possessed* and *The Brothers Karamazov*, Dante's *Divine Comedy*, Philippe Sollers's *Writing and the Experience of Limits*, Pasolini writes, "the presence of Roberto Longhi right there in the middle might have aroused curiosity: *Pierro della Francesca*, which evidently had already passed through many hands, and a whole pile of various writings, mostly magazines." Then follows "in no order, all of Swift, Hobbes, and Pound."

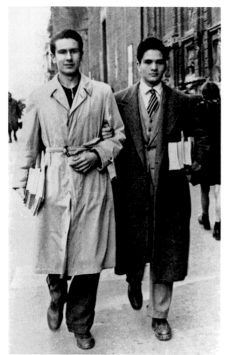

A touching series of photographs taken by Dino Pedriali in 1975 shows Pasolini—not only a writer and filmmaker, but also a painter—drawing profiles of his former professor, who had died five years earlier.

Fig. 1

Fig. 1 Anonymous, *Pasolini with Luciano Serra in Bologna*, 1939, silver photography, Cineteca di Bologna

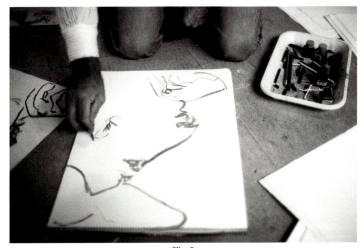

Fig. 2

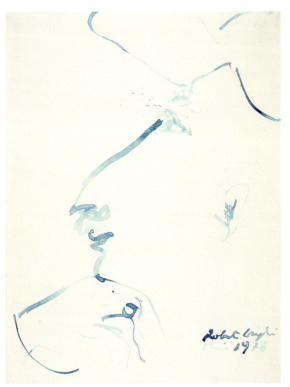

Fig. 3

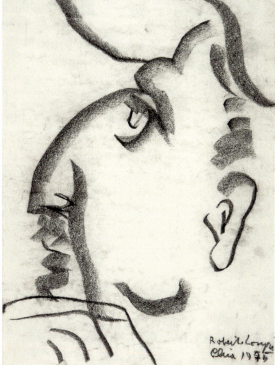

Fig. 4

Fig. 2 Dino Pedriali, *Pier Paolo Pasolini in Chia*, 1975, silver photography, Archivio Dino Pedriali / Fondazione Cineteca di Bologna
Figs. 3, 4 Pier Paolo Pasolini, *Ritratto di Roberto Longhi*, 1975, blue ink and charcoal on paper, 19 × 14½ in. (48 × 36 cm) (each), Gabinetto G.P. Vieusseux—Archivio Contemporaneo, Florence / Fondo Pier Paolo Pasolini

The knowledge of painting that Pasolini acquired from Longhi—and that he constantly cultivated in the following years—manifests itself directly and indirectly in his work as a novelist and filmmaker.

Indirectly, one sees it in his novels and poems, in the meticulousness of their descriptions, especially in the attention to color and shade. A few examples from the opening pages of Pasolini's unfinished masterpiece *Petrolio* bear witness to this: "the railings of the balconies, which were the dark red color of strawberries, stood out against the rather bleak, worn gray of the old stucco"; "a long twilight began: gold and blood red verging on bronze—lighter and lighter"; "a violet evening"; "the olive-green sky"; "the northern night was still bright: the olive was indigo, it looked like a canvas spread against the blinding light of the Third Heaven." One can tell that Pasolini was trained in the description of paintings.

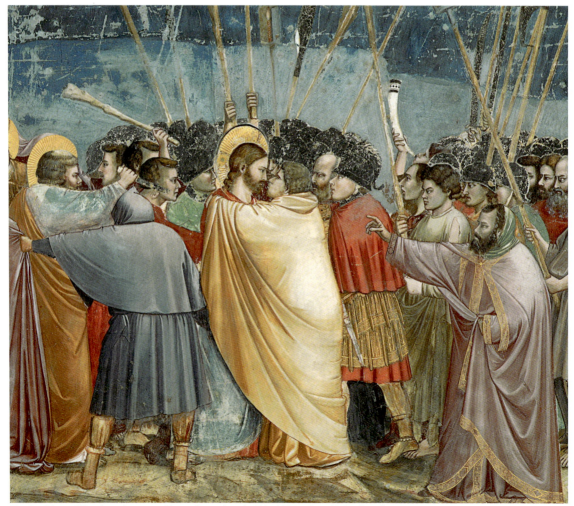

Fig. 5 Giotto di Bondone, known as Giotto, *Scenes from the Life of Christ. Kiss of Judas* (detail), 1304–1306, fresco, Scrovegni Chapel, Padua

But his visual culture is even more evident when he directly cites a painting to describe a scene. Again, at the opening of *Petrolio*: "They take a little step toward each other, as if to better scrutinize each other. And Carlo sees them in profile, immobile, like Christ and Judas in the Giotto painting." Pasolini refers here to the frescos of the Scrovegni Chapel, painted by Giotto between 1304 and 1306.

Instead of describing the scene at too-great a length, Pasolini prefers to cite a pre-existing scene, superimposing a painted image upon the written one. In this way, he creates a pictorial metaphor of almost infinite richness, since it carries not only the biblical story of Christ and Judas but also Giotto's interpretation of the story, and all the commentaries, past and future, on this interpretation.

These pictorial metaphors function just as well for landscapes, as when he writes of "the old countryside, shining as if in a Caravaggio *en plein air*"(*Petrolio*). Do we not immediately imagine the fruits of the boy from the Galleria Borghese's basket on the grape or tomato vines, the peach or apple tree limbs from which it was picked? The fecundity of the metaphor is all the more striking as we have no extant landscape by Caravaggio... The pictorial figure functions here as a metonym, with the fruit evoking its tree and the surrounding countryside.

Just as Pasolini cites paintings in his writings, he also includes more-or-less direct allusions to them in his films. What follows is not an attempt to draw up an exhaustive list of these mentions, which would be slightly tedious, but rather to offer a few telling examples, ranging from his first film in 1961 to his last about fifteen years later, in order to understand their function. This function is not merely aesthetic. More often than not, when Pasolini makes reference to a painting in a film, he does so to add meaning to meaning.

II. Rome, in the shadow of Caravaggio

In 1949, the abrupt revelation of Pasolini's homosexuality provoked a crisis: Pasolini was charged with "corruption of minors" after seducing three youths and going to masturbate behind a bush with them. Even though he was cleared of the indecency charges three years later (the families of the teenagers dropped their complaint), he had in the meantime been removed from his position as a teacher and expelled from the Italian Communist Party. He had to leave Friuli and head to Rome with his mother, "as in a novel," he later said. In the Italian capital, jobless for two years, he lived meagerly. "He roamed the city more than he inhabited it," Hervé Joubert-Laurencin writes. "He did not so much live *in* the city as live *through* it. Cruising for boys and being jobless brought him to know the unlikeliest places, or rather the most-well known places, but under their unlikeliest aspect: the Tiber, but from its embankments and bathing spots; the Vatican, but with its view of the shantytown Gelsomino; the Coliseum, but full of stray cats; the archeological promenade, but by the nocturnal light of prostitution." Pasolini's experiences would inspire five major books: two novels (*Boys Alive*, 1955, and *A Violent Life*, 1959,) two poetry collections (*Gramsci's Ashes*, 1957 and *The Religion of My Time*, 1961), and a collection of critical essays. These works made him the voice of the poor and the Italian underclass.

It was therefore as a writer that Pasolini first came to the film world, collaborating on twenty scripts—from 1954 onward—before directing *Accattone*, his first film. The launch of his film career was an artistic renewal, even if there are evident, mostly thematic, connections between his first two novels and his first two films.

Accattone (1961)

Bernardo Bertolucci, who was Pasolini's assistant for *Accattone*, spoke twenty years later of the unique atmosphere of the film shoot, with a mixture of admiration and nostalgia: "I witnessed Pier Paolo reinvent the language of cinema. A few meters of rails tossed in the dust, as if at random, became, for me, the first tracking shot in the history of cinema. And when Pasolini decided to do a pan shot or a close-up, it was as though I was witnessing the first pan shot or close-up in the history of cinema, the birth of them."

Accattone (the title character) is a small-time pimp on the outskirts of the city who has Maddalena working for him. When she gets arrested by the police, he finds himself without an income. He tries to go back to his wife whom he abandoned with their young child. It doesn't work. Accattone then sets about seducing Stella, a pure, naïve young girl, to convince her to prostitute herself. But, falling in love, he can't manage to be the pimp he once was.

All the characters in the film move about with difficulty, when they aren't dragging their feet on the shantytown's dirt roads, as if crushed by the sun. Pasolini was surely recalling here the trip to India he had just taken with Alberto Moravia. Two images merge into one: the misery of the Italian sub-proletariat of the *borgate romane* (the slums and shantytowns surrounding Rome) and that of the developing world. *Accattone* is a despairing film, since the main character's redemption does not, in the end, prevent his accidental death.

Accattone, with his sleepwalker's bearing, his fits of violence and despair, setting himself up to fail, has many traits reminiscent of certain characters in Dostoyevsky, one of the writers Pasolini admired most. Decades later, Accattone would in turn become Billy Brown, the magnificent loser in Vincent Gallo's *Buffalo '66* (1998).

Mamma Roma (1962)

Made in the wake of *Accattone*, *Mamma Roma* is the story of a boy's upbringing by his mother, a former prostitute. Raised in the countryside, Ettore is sixteen when his mother comes to find him after being "freed" by her pimp's marriage. She wants to begin a more respectable life with him as a fruit-and-vegetable seller in Rome. They move into social housing. Unfortunately, in these bleak city outskirts, it all begins again: the sudden reappearance of the mother's pimp forces her back into prostitution, and Ettore becomes a petty criminal. The boy's moral decline translates into a visible physical decline, like that of Tommasino, the main character in the novel *A Violent Life*. Ettore ends up dying in prison, in solitary confinement, strapped to a table, like a crucified body.
It is no coincidence, therefore, that Pasolini's foreshortened way of filming him irresistibly recalls Mantegna's *Lamentation of Christ*.

 No one mourns for Ettore except his mother. The film ends with the view from her window in her apartment on the fringes of Rome: a horizon clogged with hideous housing projects and, in the far distance, the golden dome of a church that seems unreachable.

 For *Mamma Roma*, Pasolini worked with one of the most famous actresses in Italy, Anna Magnani, which "confirmed, more effectively than the difficult preparation for the production of *Accattone*, his entrance into the guild of Italian filmmakers," as Hervé Joubert-Laurencin writes. From then on, the films would come one after another.

Painting or filming reality, the same approach

The influence of painting on Pasolini's films manifests itself in camera work that favors wide, frontal shots, as in a painted scene. Pasolini was aware of this: "In *Accattone*, there isn't a single shot, whether in close-up or otherwise, of a person seen from the back or the side." He composed his shots like the Renaissance painters composed their works: "I'm unable to conceive of images, landscapes, compositions of figures outside of this initial fourteenth-century pictorial passion of mine, in which man stands at the center of every perspective." That is the general spirit. But, as is often the case with Pasolini, one must immediately speak of exceptions.

Pasolini by no means limited himself to fourteenth-century painting.

At the beginning of his career as a filmmaker, particularly in his two Roman films, Pasolini aimed for realism. This explains his decision to work with non-professional actors. The experiment transposed into cinema that which he had attempted to do in poetry by writing in Friulian, a dialect livelier and more supple than Italian, which is more precisely defined and grammatically controlled.

Pasolini's realism was a search for form, but also an erotic inclination. Like all true artists, he created from within himself, from his inner world, his fantasies. While the characters in his first two films, *Accattone* and *Mamma Roma*, are from the outskirts of Rome, they belong to a specific fringe of that population: the tender and violent thugs who appeared not only in Pasolini's novels *Boys Alive* (1955), *A Violent Life* (1950), and *Petrolio* (posthumously published), but also at his side.

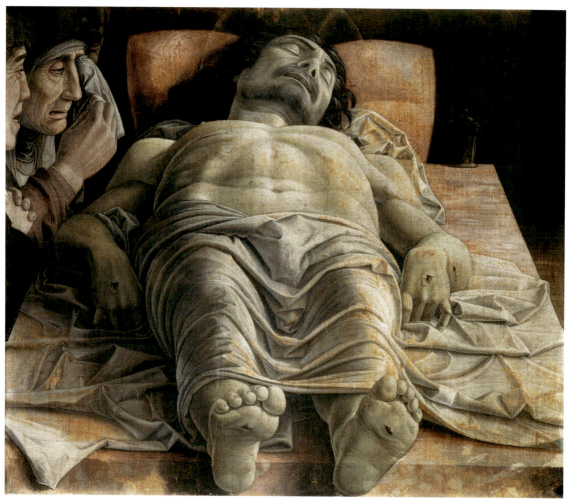

Fig. 6

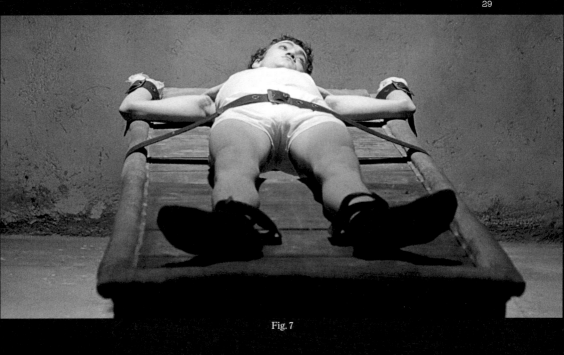

Fig. 7

Fig. 6 Andrea Mantegna, *Lamentation over the Dead Christ*, c. 1480, painting on canvas, 27 × 32 in. (68 × 81 cm), Pinacoteca di Brera, Milan
Fig. 7 *Mamma Roma*, 1962

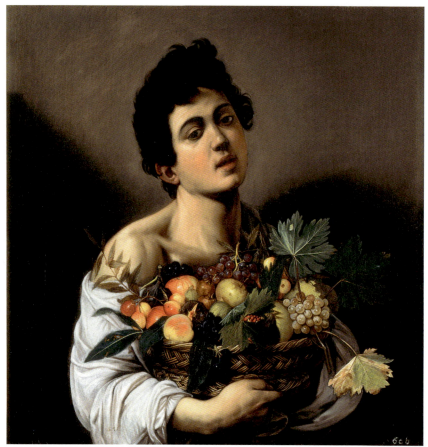

Fig. 8

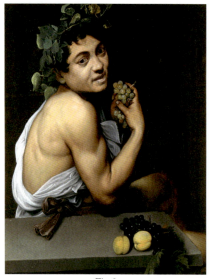

Fig. 9

Fig. 10

Fig. 8 Michelangelo Merisi da Caravaggio, known as Caravaggio, *Boy with a Basket of Fruit*, 1593–1594, oil on canvas, 27½ × 26½ in. (70 × 67 cm), Galleria Borghese, Rome
Fig. 9 Michelangelo Merisi da Caravaggio, known as Caravaggio, *Young Sick Bacchus*, c. 1593, oil on canvas, 26½ × 21 in. (67 × 53 cm), Galleria Borghese, Rome
Fig. 10 *Accattone*, 1961

Fig. 11 *Mamma Roma*, 1962

Fig. 11

Pasolini's eroticism, in this respect, coincides with that of Jean Genet, with whom he shares many other points in common. Accattone is a pimp, like Genet's Mignon-les-Petits-Pieds in *Our Lady of the Flowers*. Pasolini's *ragazzi*, meanwhile, the boys who haunt the streets of Rome (they don't live there, like today's youth from the banlieue who come to spend the day in city-centers where they won't be able to buy anything) are reminiscent of the *petites frappes*, or "little bastards," of Genet's novels.

Now, this penchant for sometimes-brutal realism—against an erotically ambiguous background—is identical to that of a great painter who likewise revolutionized the art of his time: Caravaggio (1571–1610). As we have seen, Pasolini was perfectly acquainted with Caravaggio's life and paintings, notably thanks to the studies Roberto Longhi had written on him. When one considers that Caravaggio transformed the painting of his time by choosing to realistically depict working-class models, one cannot but be struck by the similarities between Caravaggio's and Pasolini's projects, at a distance of several centuries. Pasolini, who was of course aware of this, references two of Caravaggio's most famous paintings in his first two films: *The Young Sick Bacchus* in *Accattone* and the *Boy with a Basket of Fruit* in *Mamma Roma* (a film which, significantly, he dedicated to Roberto Longhi). In the first film, he contents himself with an allusion; in the second film, he evokes the painting explicitly—an homage to an artist who, like Pasolini himself, had made Rome his adopted city.

Fig. 12 Agnolo di Cosimo, known as Bronzino, *Portrait of a Young Man with a Book*, c. 1535, oil on wood panel, 37½ × 29½ in. (95.6 × 74.9 cm), The Metropolitan Museum of Art, New York
Fig. 13 *Accattone*, 1961

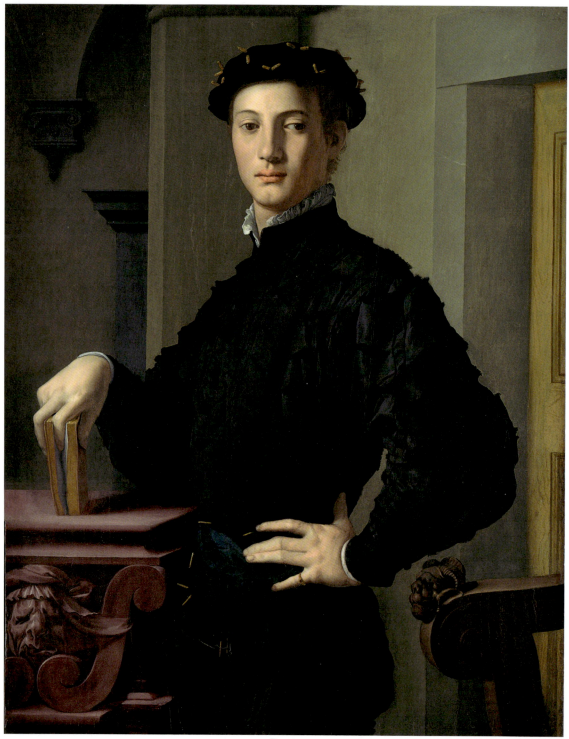

Fig. 12

Fig. 13

Caravaggio's influence is not limited, however, to these instances; it runs deeper, permeating the overall aesthetic of the two films. Pasolini gave instructions to develop the Ferrania film stock in a way that would "harshen the image"—as Tonino Delli Colli, the director of photography recalled—or, in other words "heighten the contrast" thus adapting to cinema the chiaroscuro that made Caravaggio famous.

While the Baroque painter Caravaggio is indeed the one who exerted the greatest influence on the look of Pasolini's first two films, we might note that, in *Accattone*, Pasolini also evokes one of the well-known works of the Mannerist painter Bronzino. Though the model is less sensual than the bad boys portrayed by Caravaggio, it is no surprise that this *Portrait of a Young Man with a Book* (c. 1535) caught Pasolini's eye.

Looking further back, Pasolini also took inspiration from Leonardo da Vinci. *Mamma Roma* opens with an irreverent quotation of one of the most famous works in the world, *The Last Supper*, a 15 ft. 1 in. × 28 ft. 10½-in. (460 × 880-cm) tempera painting that Leonardo made between 1495 and 1497 for the refectory of the Dominican Convent of Santa Maria delle Grazie in Milan.

"The wedding feast," as Hervé Joubert-Laurencin writes, "brings together a group of Roman pimps straight out of the world of *Accattone*, and the family of the bride, a stout, flat-nosed peasant-woman: rustics, country bumpkins." This

Fig. 14 *Mamma Roma*, 1962
Fig. 15 Leonardo da Vinci, *The Last Supper*, 1495–1497, tempera wall painting, 15 ft. 1 in. × 28 ft. 10½ in. (460 × 880 cm), Santa Maria delle Grazie, Milan

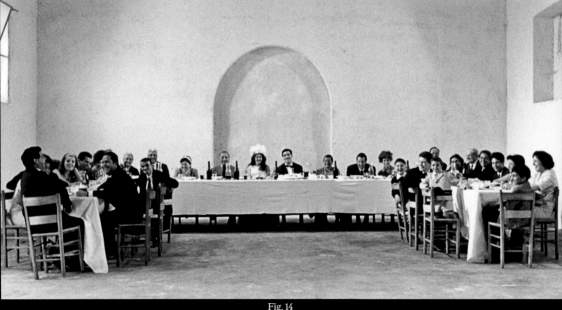

Fig. 14

pictorial quotation is a twofold sacrilege: vis-à-vis Leonardo (reality is depicted crudely here, a far cry from the idealization of the original wall painting), and vis-à-vis Christ (these pimps would make for quite scandalous apostles…).

With his first two films fundamentally influenced by the classic Italian painters, Pasolini resolutely set himself in the line of Roberto Longhi. There was, however, one exception: Giorgio Morandi (1890–1964). Here was a contemporary painter. Morandi was born in Bologna, a city he passionately loved, to the extent of almost never leaving it. As the exhibition *Pasolini Pittore* (*Pasolini Painter*; Galleria d'Arte Moderna, October 29–April 16, 2023) demonstrated, Pasolini admired Morandi very early on. His paintings were an integral part of the master's thesis project Pasolini proposed to Longhi in one of his letters from the summer of 1942: "Twentieth-century Italian painting (a subject for which I already possess fairly advanced, almost passionate preparation)." In the end, Pasolini would not complete this thesis (he lost the manuscript during the unrest following the Badoglio Proclamation on September 8, 1943), but he paid discreet homage to Morandi in a scene from *Accattone* where we see a crouching child arrange empty bottles in the manner of the painter.

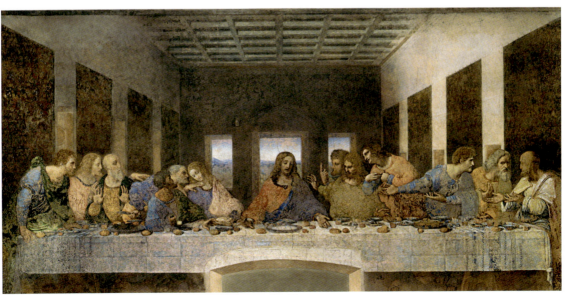

Fig. 15

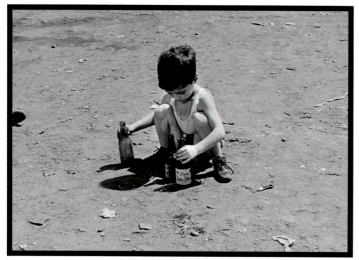

Fig. 16

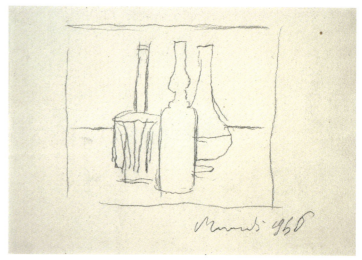

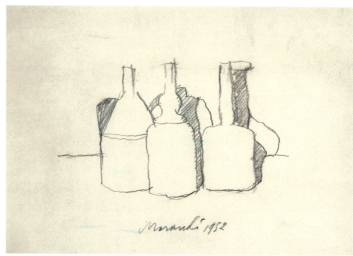

Figs. 17, 18

Fig. 16 *Accattone*, 1961
Fig. 17 Giorgio Morandi, *Natura Morta*, 1946, pencil on paper, 7 × 10 in. (17.5 × 24.8 cm), Museo Morandi / Settore Musei Civici Bologna
Fig. 18 Giorgio Morandi, *Natura Morta*, 1952, pencil on paper, 9½ × 13 in. (23.5 × 32.7 cm), Museo Morandi / Settore Musei Civici Bologna
Fig. 19 Federico Fellini, *La Dolce Vita*, 1960

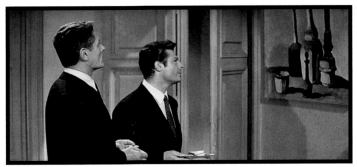

Fig. 19

The scene also echoes another, from *La Dolce Vita* this time, which had come out in theaters the previous year. Fellini's scene shows the main character, Marcello (Marcello Mastroianni) admiring a Morandi painting that belongs to his friend Steiner (Alain Cuny). Marcello says "The objects are immersed in a dreamlike light, yet painted with such detachment, precision, and rigor, that you could almost touch them. It's an art where nothing is coincidental." Now, this is precisely one of the three scenes in the script of *La Dolce Vita* that, at Fellini's request, Pasolini collaborated in writing.
In *Accattone*, Pasolini seems to have wanted to confirm Marcello's intuition through images: Aren't the bottles in the crouching child's hands a Morandi you can touch?
In Pasolini's films, too, nothing is coincidental.

III. Sacred films and religious painting

Cinema is a means of expression that reaches a larger audience than other art forms. For this reason, it has been subject to particularly close censorship from state and ecclesiastical authorities. The scarcity of sacrilegious representations on film (especially when compared to the many sexual transgressions) might lead one to think that the taboo against blasphemy is one of the strongest prohibitions in cinema. The situation is, however, more complex. As Amos Vogel noted in his 1974 essay *Film as a Subversive Art*, "another factor comes into play: the relative lack of interest in the subject among both audiences and filmmakers. Religion is simply not the order of the day as far contemporary cinema is concerned."

The two sacred films *La Ricotta* (1963) and *The Gospel According to Matthew* (1964) are, in this respect, exceptions to the rule. They place Pasolini at the crossroads of two lineages: on one side, the handful of filmmakers like Dreyer (*Day of Wrath*, 1943), Bresson (*Diary of a Country Priest*, 1951) and Rivette (*The Nun*, 1966) who seriously explored religious topics; on the other side, the equally scarce number of filmmakers (almost all from the Surrealist movement) who worked with a subversive, even anticlerical, objective. Luis Buñuel, with *L'Age d'Or* (1930), *Viridiana* (1961) and *The Milky Way* (1969), is probably the best representative of the latter group.

Pasolini is at the intersection of these two lineages because his discourse on religion is not uniform. Though he is critical of the Church as an institution, he does not denounce Christianity as such. On the contrary, he even goes so far as to lament its disappearance in a society more and more affected by consumerism and the loss of traditional reference points.

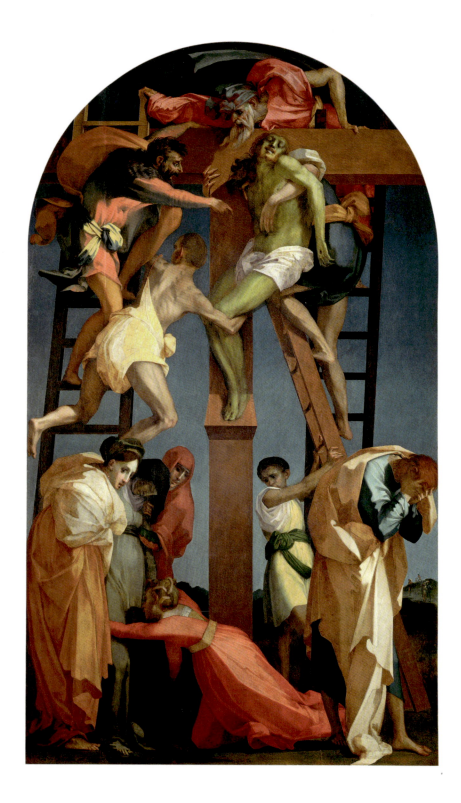

Fig. 20 Giovanni Battista di Jacopo, known as Rosso Fiorentino, *Descent from the Cross*, 1521, oil on wood panel, 12 ft. 3½ in. × 6 ft. 5 in. (375 × 196 cm), Pinacoteca e Museo Civico, Volterra

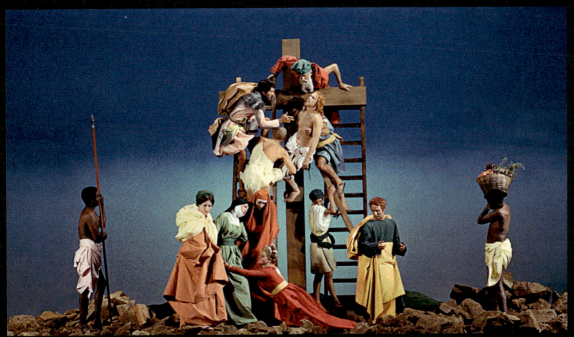

Fig. 21　*La Ricotta*, 1963

La Ricotta (1963)

Pasolini shocked audiences. He had warned them in *Vie Nuove*, the Communist Party weekly, "Every poetic work is profoundly innovative, and therefore scandalous"(September 20, 1962). Like Jean Genet before him and Pierre Guyotat, Pasolini found himself on trial. Throughout his life, provincial prosecutors pressed charges against him (thirty-five times in all) on grounds that were mostly either ridiculous—so called thought-crimes—or pure and simple fantasy (Pasolini allegedly held up a gas station…). But it was his film *La Ricotta* that caused him the greatest legal trouble. The thirty-five-minute short led him to be brought to court and sentenced to four months in prison for contempt of religion—a sentence fortunately struck down on appeal.

But what exactly is this short film? *La Ricotta* was part of an anthology film eccentrically titled *RO.GO.PA.G,* for ROsellini, GOdard, PAsolini, and Gregoretti. The title card reads, "Four stories by four authors who limit themselves to recounting the joyous beginning of the end of the world." In the case of Godard's *The New World*—the most accomplished of the four films—it is more a question of passing from the old world to a new world from which wild, passionate love has vanished, after an atomic bomb explodes 39,400 feet (12,000 m) above Paris. The consequences of the radioactive contamination are so slight that at first nothing seems to have changed. But the main character soon witnesses his relationship with his girlfriend fall apart, and he begins to feel "odd." *La Ricotta* also stages the end of the world, or rather a world: that of traditional, even archaic, Italy, steeped in religion. Pasolini was one of the first to describe the dissolution of that Italy by consumerism. This was also the angle from which he chose to defend the film in a pointedly Marxist interview in *Il Messagero*. The Catholic religion had become, he said, "a weapon in the class struggle or, at best, a means of getting rich. That's what happens in my film where an unscrupulous producer and a filmmaker who sold his soul to the devil make a Technicolor film that is a real sacrilege, a shameless act of moral and religious insensitivity." In this light, *La Ricotta* becomes an all-out attack—a "Lutheran" attack, to take up the title of Pasolini's famous book published after his death)—against the pharisees and against the capitalism of the 1960s. For Pasolini, those were two faces of

Fig. 22 Jacopo Carucci, known as Jacopo da Pontormo, *Deposition*, 1526–1528, oil on wood panel,
10 ft. 3 in. × 6 ft. 3½ in. (313 × 192 cm), Capponi Chapel, Santa Felicità Church, Florence
Fig. 23 *La Ricotta*, 1963

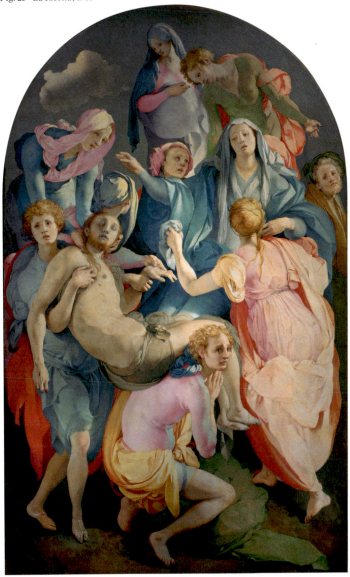

Fig. 22

Fig. 23

the same coin, since he saw religion's contemporary state of corruption as merely a consequence of the new social order. Accordingly, the film was shot in a field on the outskirts of Rome, with the same drab housing projects of *Mamma Roma* on the horizon.

La Ricotta has no real plot or narrative progression (we see part of the shooting of a film about the passion of Christ, during which a poor extra playing the good thief dies of indigestion on a cross), but that is only because its interest lies elsewhere.

Pasolini's entire oeuvre can be considered, in one way or another, autobiographical. In *La Ricotta*, he gives us his self-portrait as a filmmaker. But this self-portrait is ambiguous, to say the least, as the filmmaker played by Orson Welles alternates "between sublime stupidity and the sharpest wit"(Rinaldo Rinaldi). The opinions Pasolini lends the filmmaker are his own. Certain phrases are even taken directly from Pasolini's own poems. But if this "filmmaker sold his soul to the devil," as Pasolini said, then isn't this his confession of what he feels he has done by abandoning literature for cinema? As André Bazin once wrote, "Cinema is an impure art." And, we might add, the most capitalist art of all.

But what makes *La Ricotta* an important film, even more than its autobiographical dimension, is the way it plays with the history of images. This black-and-white film includes two tableaux vivants in Technicolor. Each is a remake of a famous Mannerist painting, two descents from the cross: Rosso Fiorentino's, painted in 1521 and kept today at the Pinacoteca di Volterra; and Pontormo's, painted between 1526 and 1528 and located in the Capponi Chapel of the church of Santa Felicita in Florence. This was Pasolini's first time using color in a film, the famous Technicolor process borrowed from commercial Hollywood cinema. That is probably the root of the "sacrilege": to film a descent from the cross in color, so as to make it as spectacular as possible and maximize the profit. Such a "shameless" commodification of this particularly poignant moment in the passion of Christ can only be called "sacrilege."

Fig. 24 Paul Ronald, *Pier Paolo Pasolini Staging One of the Two Tableaux Vivants of* La Ricotta, 1963, silver photography, Maraldi Collection

Fig. 24

Pasolini's interest in Mannerism is noteworthy since it was by no means a given in the early 1960s. At the time, Mannerism was poorly viewed, overlooked in favor of the Renaissance (which precedes it) or the Baroque (which follows it). The term itself is a late invention from the 1920s that is not easy to define. Mannerism applies only to works of a specific type, made by a few artists, between approximately 1520 and 1590, mainly in Rome and Florence. In his *Poem in the Shape of a Rose*, Pasolini speaks of "the taste for sweet and great mannerism, that touches with its tenderly robust whim the roots of living life." If you had to describe it in a more objective manner, you might say that Mannerism is distinctive for its frequency of nudes, strangeness of poses, excess of muscles, violence of color, and its striving for expressiveness and virtuosity at the expense of the subject or theme—which, relegated to the background or lost among unrelated figures, is sometimes difficult to identify. This is the case in Pontormo's beautiful *Saint Sebastian* who, rather than being pierced by arrows, holds one in his left hand. Hardly anything here evokes the idea of martyrdom, except the saint's sad, almost pained, expression.

And such is also the case in the same Pontormo's wonderful *Deposition* (1527), which was painted in the same period and from which the ladder and even the cross itself have disappeared. The painting, made for the chapel of the church of Santa Felicita in Florence, astonishes with its dazzling, unbelievable pinks, blue-greens, and orange-reds. Hardly anything in this strange masterpiece is familiar except the posture of the dead Christ, imitated from Michelangelo's *Pièta*. By choosing this painting among so many other possibilities, Pasolini showed his intimate familiarity with the history of art. His approach is more personal than academic.

Fig. 25 Jacopo Carucci, known as Jacopo da Pontormo, *Saint Sebastian*, n.d., oil on wood panel, 21 × 15½ in. (53 × 39 cm), Bruckner Collection

Though Caravaggio's influence here pales in comparison to that of the Florentine Mannerists, it is not completely absent from this third film. One detects it in an important element of the set at the beginning and end of *La Ricotta*: a table of food. Hervé Joubert-Laurencin has rightly noted that this table is "treated as a still-life, or as a stereotypical, symbolic element of the scene, such as one might find in the works of Caravaggio." The arrangement evokes, for instance, a detail in the *Supper at Emmaus* (c. 1601). All the same, though Caravaggio's influence is visible here, it was undoubtedly less decisive than that of the Baroque Flemish painters such as Pieter Claesz (1597–1661), who excelled in this particular genre of "breakfast piece." In addition to the shot's highly pictorial arrangement—further proof that Pasolini was indeed referring to painting here—the banquet table is filmed in color.

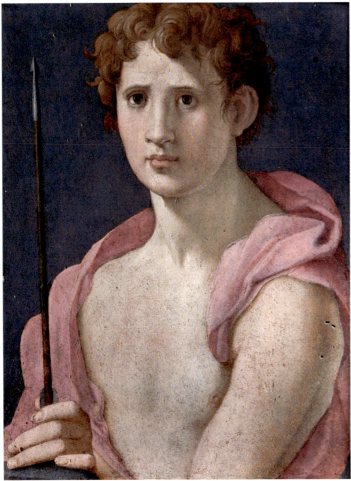

Fig. 25

Fig. 26 Michelangelo Merisi da Caravaggio, known as Caravaggio, *Supper at Emmaus* (detail), c. 1601, oil on canvas, 55½ × 77 in. (141 × 196.2 cm), National Gallery, London
Fig. 27 Pieter Claesz, *Still Life with Crab, Fruits, Salt Cellar, Berkemeyers, and a China Bowl with Olives*, 1651, oil on wood panel, 20½ × 33 in. (52.5 × 84 cm), Inna Bazhenova (Samorukov) Collection, Monaco
Fig. 28 *La Ricotta*, 1963

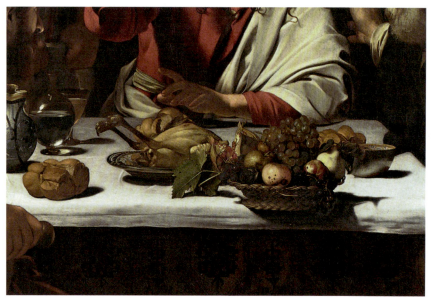

Fig. 26

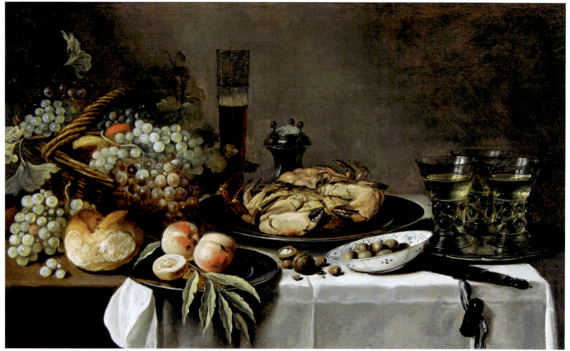

Fig. 27

Fig. 28

There is one last painting we must speak of. It is by a minor master, Vincenzo Campi, known both for his altarpieces and his genre paintings. Pasolini must have discovered him thanks (once again) to Roberto Longhi, who saw the realism of Campi's beautiful *St Matthew and the Angel* (1588) as an important precursor to Caravaggio. The painting I have in mind is *The Ricotta Eaters* (c. 1580). The resemblances between this painted scene and the film are too striking to be coincidental. Didn't Pasolini base certain shots of his on paintings, and didn't he look for actors that resembled the painted models? This painting plausibly offered him a compelling model for the character of Stracci, the unfortunate extra destined to die on the cross of indigestion after eating a plate of ricotta. The painting may even have given Pasolini an idea for part of the script. If you look closely at Vincenzo Campi's image, you see that the ricotta marked by the three spoon-strokes resembles a skull. While a too-hasty viewer might take this for a genre scene, it is in fact a *memento mori*... The idea of death is there, underlying it all—and confirmed by the presence of a fly resting on the cheese—the very death that comes to the glutton Stracci at the end of the film.

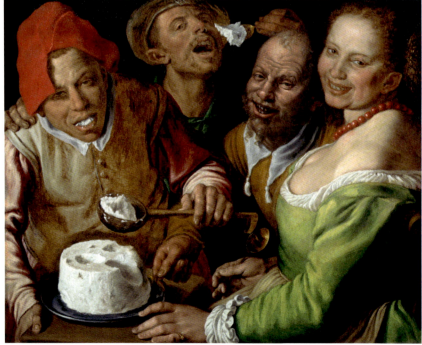

Fig. 29

Fig. 29 Vincenzo Campi, *The Ricotta Eaters*, c. 1580, oil on canvas, 30½ × 35 in. (77 × 89 cm), Musée des Beaux-Arts, Lyon
Fig. 30 *La Ricotta*, 1963

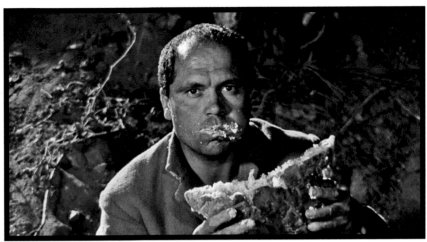

Fig. 30

The Gospel According to Matthew (1964)

Before any commentary, we have to call to mind a famous painting of Caravaggio's, as invited to do by Hervé Joubert-Laurencin: *The Calling of Saint Matthew*. We see a slant of light illuminating a scene that looks more like the pub in *Accattone* than a biblical setting. Only Jesus and Peter are dressed in the ancient style. Matthew is there, at the edge of a table, counting money (he is a tax collector), surrounded by his underlings who look more like the street boys in *Ragazzi di Vita*... Matthew, the gang leader. How could this image not have pleased Pasolini? This is how he will portray Jesus and his apostles in *The Gospel According to Matthew*.

None of this stops Pasolini from being faithful to the biblical text, whose order of events and developments the films maintains. The entire prologue, which shows Jesus' childhood, is silent. Then the dialogues follow the scriptures word-for-word. In his letters, as he was preparing for the film, Pasolini wrote that he wanted to "follow the Gospel of Matthew point by point, without turning it into a script or an adaptation. Faithfully translate it into images, without a single omission or addition to the story." In his concern for philological exactitude, he even collaborated with members of the Jesuit

Fig. 31 Michelangelo Merisi da Caravaggio, known as Caravaggio, *The Calling of Saint Matthew*, c. 1600, oil on canvas, 10 ft. 7 in. × 11 ft. 2 in. (322 × 340 cm), Contarelli Chapel, San Luigi dei Francesi, Rome

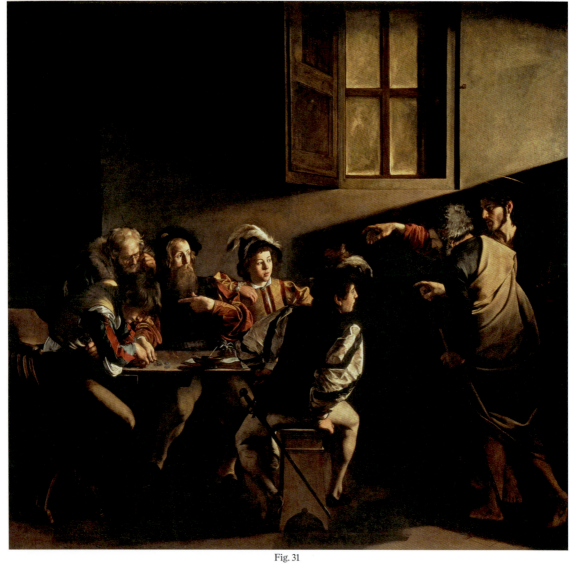

Fig. 31

association Pro Civitate Christiana, particularly with regard to the Italian translation of Jesus' words. This scrupulous fidelity to the scriptures is at once the principle interest of the film and one of its limitations.

Pasolini approached the question of where to shoot the film with as much care as he approached the dialogues. After a location-scouting trip to Israel in the company of two Jesuit priests, he decided the country was too modern and industrialized to shoot a film supposed to take place in Jesus' time. The agricultural regions of Puglia, Calabria, and Lucania, with their vast desert-like expanses, seemed better suited to reconstructing the biblical story. In this decision he followed the example of Caravaggio, who set the action of *The Calling of Matthew* in a décor visibly different from that of the scriptures, without the slightest attempt at a historical reconstruction. After experimenting here for the first time with this principal of analogy, typical of classical painting, Pasolini would go on to use it for other films, most strikingly his last film *Salò, or the 120 Days of Sodom*.

The question of the image, or general aesthetic, of *The Gospel According to Matthew* was complex as well. Pasolini understood he could not continue using the same system of pictorial references as in his previous films. The Caravaggesque model of mixing high and low, sublime and trivial, had worked for *Accattone* and *Mamma Roma* because it corresponded to Pasolini's aim: "to look at pagan reality through religious eyes," as Hervé Joubert-Laurencin phrased it. For a Christian film, such a model would run the risk of appearing facile at best, or causing the film to sink into kitsch, at worst. The goal of *The Gospel According to Matthew* is to make us feel the charismatic presence of the characters, and of Jesus especially. Pasolini therefore decided to abandon Caravaggio's plebeian realism in favor of the restrained, hieratic style of Piero della Francesca. By selecting Margherita Caruso for the role of the young Mary, with her full lips and large, sleepy eyes, he gave life to the *Madonna del Parto* (c. 1460). Pasolini nevertheless replaced the heavy canopy curtains with a stone arch crowning her presence, in what Daniel Arasse has described as an "architectural metaphor" that designates Mary as a *locus,* tabernacle, house of the living Word.

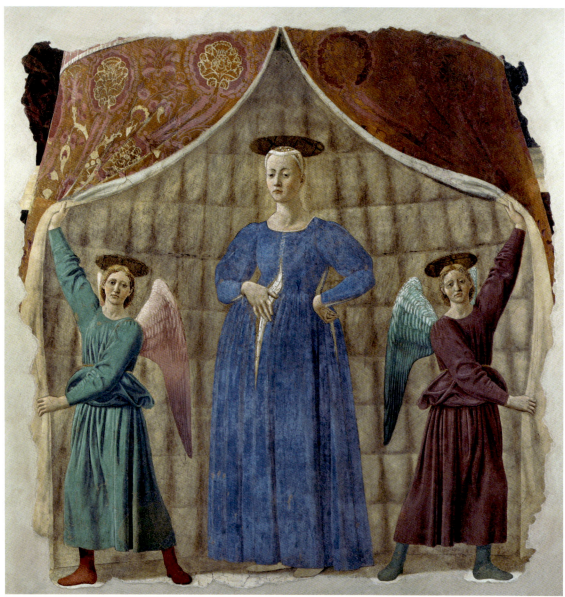

Fig. 32

Fig. 32 Piero della Francesca, *Madonna del Parto*, c. 1460, fresco, 8 ft. 6½ in. × 6 ft. 8 in. (260 × 203 cm), Museo della Madonna del Parto, Monterchi
Figs. 33, 34 *The Gospel According to Matthew*, 1964

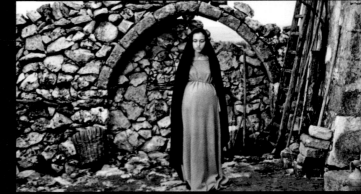

Fig. 33

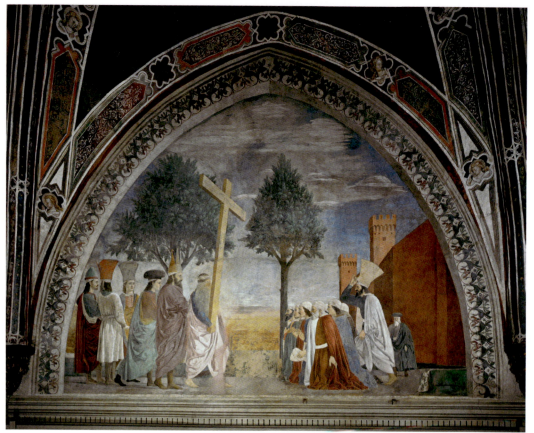

Fig. 35

Fig. 36

Fig. 35 Piero della Francesca, *The Exaltation of the Cross. The Legend of the True Cross* (detail), 1452–1466, fresco, Capella Bacci, Basilica di San Francesco, Arezzo
Fig. 36 *The Gospel According to Matthew*, 1964

Fig. 37 Angelo Novi, *Pier Paolo Pasolini on the Set of* The Gospel According to Matthew, 1963, silver photography, Cineteca di Bologna / Fondo Angelo Novi

Fig. 37

To give the feeling of Jesus' transcendence, Pasolini made new technical choices. While he had formerly limited himself to using two lenses, a 50 mm and a 75 mm for closeups, he now opted for wide-angle lenses (18 and 25mm) and low-angle shots. In doing so, he accentuated Enrique Irazoqui's resemblance to Christ as envisioned by El Greco.

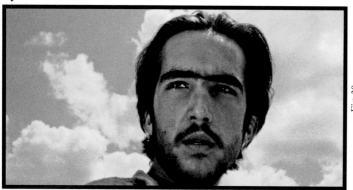

The very project of *The Gospel According to Matthew*, together with its reinvented aesthetic, appears to present a turning point for Pasolini. It opens a new period in his filmography, a period freed from the dominant influence of Caravaggio, but not of painting. The work to come even seems prefigured by one particularly striking moment in *The Gospel According to Matthew*: that of the "kiss of Judas," wonderfully analyzed by Hervé Joubert-Laurencin. The moment of the kiss, he writes, "consists entirely of a montage sequence (an abrupt shot/counter-shot between the two figures heading toward each other from a distance, then their faces seen in close-up. In this way, the two shots evoke—not by a figurative reconstruction, but dynamizing the gesture without exaggerating the movement— Giotto's version, entirely composed around the burning center of the image." Giotto, major painter of the Italian fourteenth century, will reappear shortly.

Fig. 5

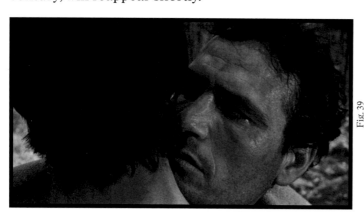

Figs. 38, 39 *The Gospel According to Matthew*, 1964

Fig. 40 Doménikos Theotokópulos, known as El Greco, *Christ in Prayer*, 1585–1597, oil on canvas, 24 × 18 in. (61 × 46 cm), National Gallery, Prague

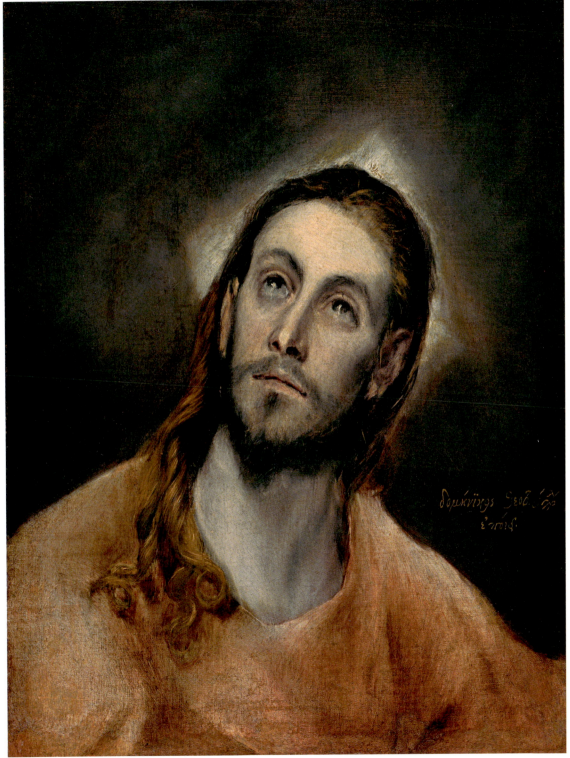

Fig. 40

IV. A dialogue with the classics

The roots of Pasolini's tragic conscience are undoubtedly to be found in his own life (the public shame of his homosexuality) and in the execution of his younger brother, who died a martyr's death in the mountains bordering Yugoslavia. (Having joined an anti-Fascist resistance network of Friulian regionalists, Guido Pasolini was shot to death by Italian communists on the basis of false rumors of treason—a story Pasolini incessantly wrote and rewrote throughout his life.) Pasolini's insistence on the tragedy of existence, the distinctive mark of his early films, would soon find expression in the cinematic revival of two myths inherited from ancient Greece: the stories of Oedipus and of Medea, staged in Athens in the fifth-century BCE by Sophocles and Euripides, respectively. *Oedipus Rex* came out in theaters in 1967, and *Medea*, starring Maria Callas, in 1969.

Fig. 41 Roberto Oggero, *Maria Callas and Pier Paolo Pasolini in Monaco for the Red Cross Ball*, 1969, silver photography, SBM Archives, Monaco

Pasolini would extend this dialogue with the classics through film adaptations of three important texts: Bocaccio's *Decameron*, Geoffrey Chaucer's *Canterbury Tales* (both written in the fourteenth century), and the collection of the *Thousand and One Nights*. This series of films, which Pasolini named the *Trilogy of Life*, marked another profound shift in the tone of his work. These were major hits, happy escape movies one might say. They opened the way toward a greater freedom to represent naked bodies in cinema. René Schérer writes that, through the *Trilogy of Life*, "Pasolini fulfilled, perfected, the demands of a philosophy-thought of the body by the body, as a weapon in the struggle against all forms of societies of normalization and control." Through

these three films (especially *The Decameron* and *Arabian Nights*) Pasolini indeed offered the model of an open, joyful, innocent sexuality, breaking with a Judeo-Christian sexuality racked by guilt.

The Decameron (1971)

The Decameron is a collection of one hundred short stories written in Italian by Giovanni Boccaccio between 1349 and 1353. The stories—told in turn by ten young Florentine men and women who have fled the city because of a plague outbreak—show us characters drawn from the reality of that time: merchants, notaries, bankers, craftsmen, commoners, priests, monks, peasants in the city, and so on. The principal theme is love.

Pasolini very freely based himself on Bocaccio's texts to write a script with ten stories, only three of which are directly adapted from the original work. Like his first Roman films, *The Decameron* mixes "high" and "low" culture: on the one hand, it is a subtle adaptation of a fourteenth-century work, featuring multiple allusions to classical painting; on the other hand, it is filled with trivial eroticism. *The Decameron* would thus become the first mass-market film in which an erect male organ is clearly visible (that of an alleged deaf-mute about to satisfy a nun).

In Bocaccio, sexuality appears free and easy. Most of the characters have little concern for the moral values preached by religion, preferring to rely on a kind of common-sense

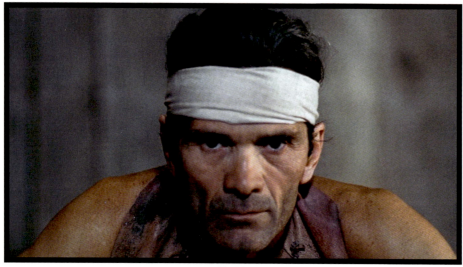

Fig. 42

resourcefulness to get themselves out of, or profit from, a situation. That is the case, for instance, of the young man mentioned above, pretending to be a deaf-mute in order to gain admittance to a convent full of young, pretty nuns!

Bocaccio's book offered Pasolini the occasion to present the public with innocent, liberated bodies—or better yet, offer

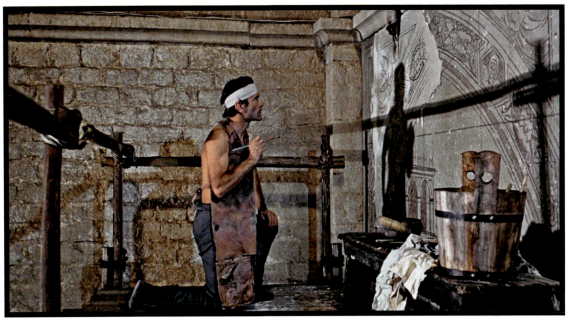

Fig. 43

these bodies up as examples. From that perspective, this seemingly light film had a political aim as well.

Hervé Joubert-Laurencin suggests that Pasolini was later brought to renounce the *Trilogy of Life* because of his "sudden awareness (perhaps performed, spectacularized, but not necessarily so) that the ground was already occupied, that the place for popular culture had already been taken by industrial society's buying-and-selling of bodies, by pornos, by an entire institutionalization of eroticism and the transgression of Judeo-Christian morality."

Whatever the status of this "philosophy-thought of the body by the body" in *The Decameron*, it is not, in my eyes, the principle interest of the film. The latter lies rather in the film's subtle combination of high and low culture. In no other film does Pasolini cite as many renowned frescos and paintings. Many shots have a painting in the background. As if he wanted to signal even more clearly painting's influence on his films,

Figs. 42, 43 *The Decameron*, 1971

Fig. 44

Fig. 45

Figs. 44, 45 *The Decameron*, 1971
Figs. 46, 47 Giotto di Bondone, known as Giotto, *Scenes from the Life of Saint Francis* (details), n.d., fresco,
Upper Church, Basilica Saint Francis of Assisi

65

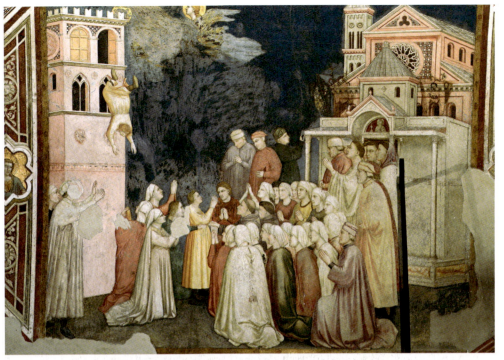

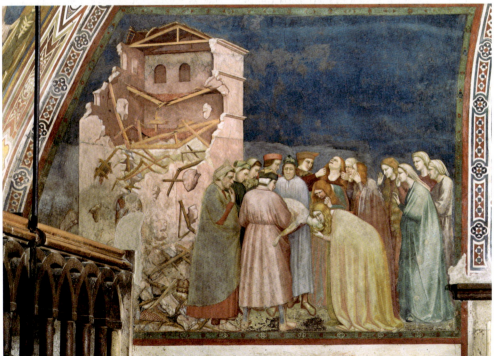

Figs. 46, 47

A Filmmaker in the School of Roberto Longhi

Pasolini (in an obvious moment of meta-cinema) not only devoted one of the ten stories to a disciple of Giotto, but even played the character himself!

The fresco we see him paint for the monastery is a replica of a Giotto fresco in the right transept of the Lower Church of the Basilica of Saint Francis of Assisi. The citation here is direct. Later, at the end of the film, another Giotto fresco is cited, the *Last Judgment*, this time as a tableau vivant. Pasolini borrows the general composition, all while introducing a modification by replacing God with the Virgin Mary carrying the infant Jesus.

For Mary herself, Pasolini once again found a model in Giotto. A close-up allows us to recognize, in the solemn features of Silvana Mangano, the monumental *Ognissanti Madonna* painted in tempera and gold on wood. (The work takes its name from the Ognissanti church in Florence for which it was painted, probably between 1300 and 1310.)

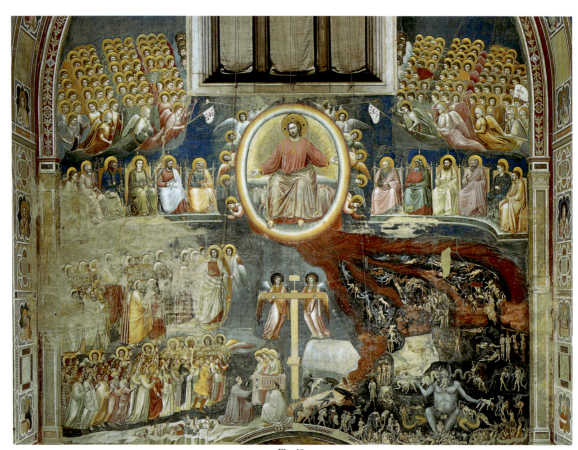

Fig. 48

Fig. 48 Giotto di Bondone, known as Giotto, *Scenes from the Life of Christ. Last Judgment*, 1304–1306, fresco, Scrovegni Chapel, Padua
Fig. 49 *The Decameron*, 1971

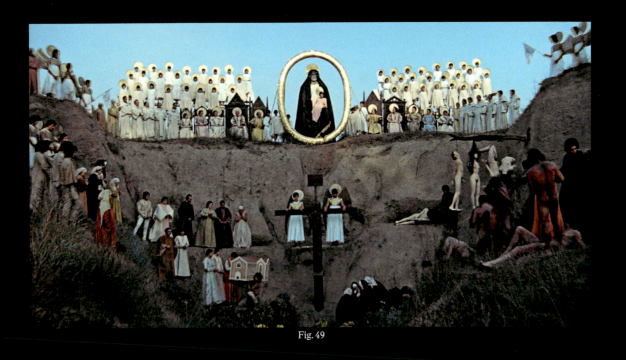

Fig. 49

Fig. 50

Fig. 50 *The Decameron*, 1971
Fig. 51 Giotto di Bondone, known as Giotto, *Ognissanti Madonna*, c. 1310, oil on wood, 10 ft. 8 in. × 6 ft. 8½ in. (325 × 204 cm), Uffizi Gallery, Florence

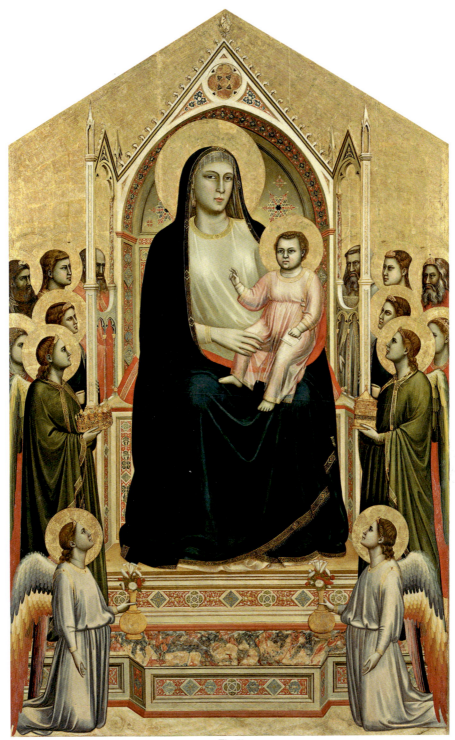

Fig. 51

A Filmmaker in the School of Roberto Longhi

In *The Decameron*, Pasolini uses three modes of quotation: integrating a work of art into the film set itself, tableau vivant, and allusion. I make this remark not to establish a precise typology—the boundaries between the three modes are often porous—but to show the richness of Pasolini's relationship to painting.

While Pasolini often expressed his admiration for the Trecento painters, particularly Giotto, *The Decameron* also shows a less-expected interest in Flemish art, through the figure of Pieter Bruegel the Elder. Near the middle of the film, Pasolini draws inspiration from Bruegel's paintings—with their unmistakable, teeming compositions—to signal that Franco Citti's character Ciappelletto, a notary guilty of all impieties and crimes, has indeed completed a long journey "to the north." An approximately one-minute sequence directly inspired by three Bruegel paintings--*The Fight Between Carnival and Lent*, *The Triumph of Death*, and *The Land of Cockaigne*-- allows the film to establish the new setting after the ellipsis of the journey (which has merely been mentioned in a previous dialogue). As is often the case with Pasolini, the use of pictorial models isn't solely an aesthetic concern. Here, it serves both to enrich the film with unexpected, lavish images and create an effect of verisimilitude.

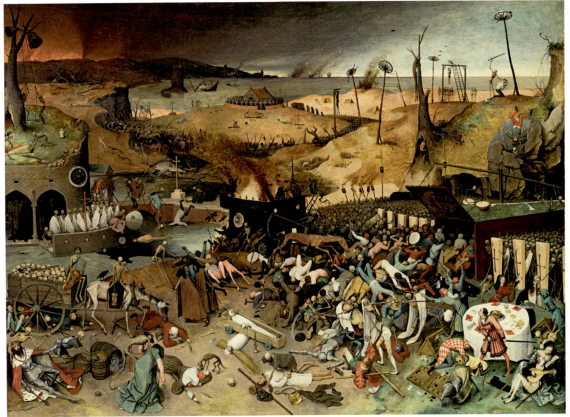

Fig. 52

Figs. 53, 54

Fig. 52 Pieter Brueghel the Elder, *The Triumph of Death*, 1562, oil on wood panel, 46 × 64 in. (117 × 162 cm), Museo del Prado, Madrid
Figs. 53, 54 *The Decameron*, 1971

Fig. 55

Fig. 56

Fig. 55 Pieter Brueghel the Elder, *The Fight Between Carnival and Lent,* 1559, oil on wood panel, 46½ × 65 in. (118 × 164.5 cm), Kunsthistorisches Museum, Vienna
Fig. 56 Pieter Brueghel the Elder, *The Land of Cockaigne,* 1567, oil on wood panel, 20½ × 30½ in. (52 × 78 cm), Alte Pinakothek, Munich
Figs. 57, 58, 59 *The Decameron,* 1971

Figs. 57, 58

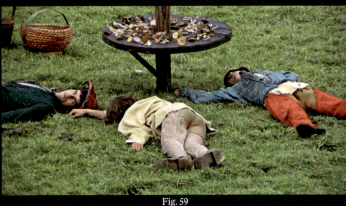

Fig. 59

The Contemporary Extreme

Fabio Mauri, *Intellettuale. Il Vangelo Secondo Matteo di/su Pier Paolo Pasolini*, 1975, silver photography, Galleria Comunale d'Arte Moderna, Bologna

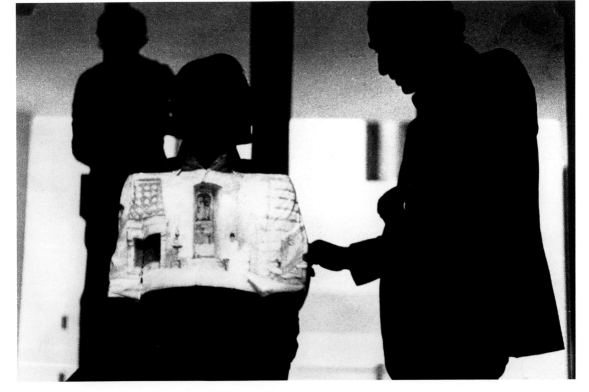

I.
Theorem
(1968)

Theorem exists both as a book and as a film. This undoubtedly contributed to the *Theorem* text's experimental form, situated between novel and script. Pasolini began writing the book in summer 1966, at the same time as he was working on the script of *Oedipus Rex*. The shooting of the film, however, took place two years later, just after the book was published. The film is therefore both the cinematographic adaptation of a text by its own author and the outdoing of that very text. The film outdoes the novel because Pasolini, faced with the necessity of giving his story a visual form, decided to place it under the aegis of one of the greatest painters of his time: Francis Bacon.

Francis Bacon: A model

Theorem is a particularly ambiguous film. To attempt to define it, one must refer to the book's epigraph. This is the key: "But God led the people about, through the way of the wilderness." The words are the first half of a verse from Exodus, 13:18. They may be interpreted to mean that it is not always the most direct or the most evident path that leads to God. In this perspective, *Theorem* becomes the story of a family's conversion by roundabout ways.

Pasolini himself presented his film as "a religious story: a God—beautiful, young, fascinating, blue-eyed—comes to a bourgeois family. And he loves them all." He also offered the following, complementary, description: "It is about a divine visitor's arrival in a bourgeois family. The visitation overturns everything the bourgeois knew about themselves; this guest has come to destroy. Authenticity, to use an old word, destroys inauthenticity." And, indeed, the beautiful young stranger (played by Terrence Stamp), whose arrival in this rich Milanese family is announced by telegram, brings subversion along with

him. One after the other, his cold beauty casts into his arms and into his bed the servant Emilia, the son Pietro, the mother Lucia, the daughter Odetta, and the father Paolo.

Theorem is undeniably a religious film, since it depicts a divine visitation, but it is also a violent critique of the bored, sedentary, overstuffed bourgeoisie—a critique that foreshadows the *Corsair Writings*, *Lutheran Letters*, *Petrolio*, and *Salò*. Pasolini tells us on the novel's first page: "It concerns a petit bourgeois family—petit bourgeois in the ideological not the economic sense." This family from the 'industrial bourgeoisie" is "rich," unlike their guest, a Rimbaldian vagabond only rich in gifts: the gift of beauty, unconstraint, sex, freshness. From this point of view, *Theorem* is also a film about the supremacy of youth. Pasolini portrays youth as divinely troubling. The desire that it arouses, and the fulfilment of that desire, reveals the characters' true nature to themselves. Sex is a revelation, but an ambiguous revelation that casts everyone into confusion. In *Theorem*, sex bewilders rather than saves.

With regard to Pasolini's filmography, *Theorem* was the crucial film where he broke with neorealism and turned toward parable. He insists on this in chapter five of the book: "We repeat, this is not a realistic story, but a parable." Pasolini's moral tale affirms the revolutionary power of sex: not of an obligatory and therefore falsely "free" love, but of an irrepressible, disordering pansexuality. (There can be no doubt he is specifically thinking of homosexuality—which in 1968 was still known in Europe as *inversion*, as René Schérer has noted.) The bisexual angel of *Theorem* appears, then, as a distorted reflection of the two angels in Genesis that God sends to Sodom, and whose arrival leads to the destruction of the city. In this present case, it is the angel who is the seducer (in the Biblical story, it was the Sodomites who desired the angels); he subverts, foretells, poses questions without answers. When he finally leaves the family, they all wander toward their respective fates.

Fig. 60 Jesse Fernández, *Francis Bacon in his Studio, 7 Reece Mews, London*, 1977, silver gelatin print, 12 × 15½ in. (30 × 40 cm), Francis Bacon MB Art Foundation / MB Art Collection

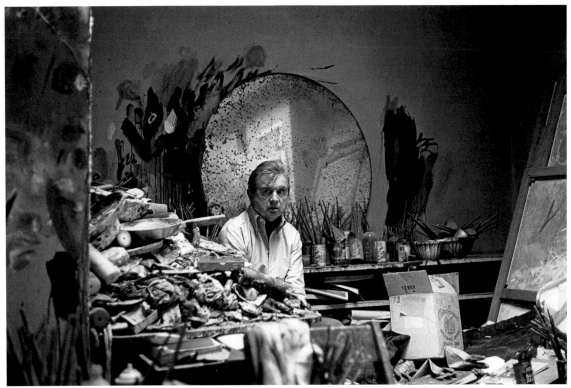
Fig. 60

It is the nature of parables to be interpreted and therefore to offer several levels of meaning. And yet this requires time to think about them. Now, contrary to reading, a film in a theater advances at its own pace: you cannot slow it down or skip back a few minutes. The use of symbols in film therefore requires a greater degree of transparency than in a book. Pasolini, who fully understood this, modified certain details in *Theorem* (the book) to make *Theorem* (the movie) more comprehensible. This is notably the case at two important moments when Pasolini refers to the works of Francis Bacon, first by including them on screen, and then by visually quoting them.

The first reference to Francis Bacon comes during a scene between the mysterious visitor and Pietro, the son. In the book, after the guest has "offered to the son as well his silken member, more mature and powerful," Pasolini describes them seated side by side on the bed and leafing through a book of color prints. As the chapter title indicates, this is a "new initiation"—aesthetic, this time. The two characters' eyes linger upon a painting by Wyndham Lewis, "a friend of Pound, an American," the text specifies. "What picture is it? The date is certainly somewhere between 1910 and 1920. It does not belong to the culture of Cubism, that sumptuous culture. It is spare, extremely spare. Perhaps it is Futurism [...] a drawing with colored surfaces, constructed like a perfect machine, and so rigorous as to have reduced the picture to the bare bones." It is manifestly an avant-garde work, difficult, not much to the taste of the bourgeoisie. What takes place in the scene is clear. The painting forges a complicity. Pietro and his guest "glance at each other, in this mysterious closeness born in the night" they have just spent together. This is Pietro breaking the bounds and finding his calling as an artist.

The entire chapter of *Theorem* (the book) is constructed around Lewis's abstract painting. In *Theorem* (the film), however, Pasolini chooses to replace it with more recent paintings. Pietro and his guest are still shown sitting side by side, but they are instead leafing through a Francis Bacon monograph. The camera lingers on the pages long enough for us to recognize Bacon's *Three Studies for Figures at the Base of a Crucifixion* (1944) and *Two Figures* (1953), bodies intertwined, merged in love or struggle. We also glimpse *Fragment of a Crucifixion* (1950), the painting of an indistinct pale figure screaming on the cross.

Figs. 61, 62, 63, 64 *Theorem*, 1968

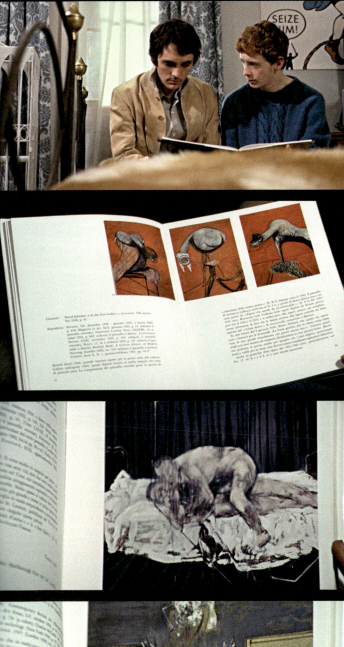

Figs. 61, 62, 63, 64

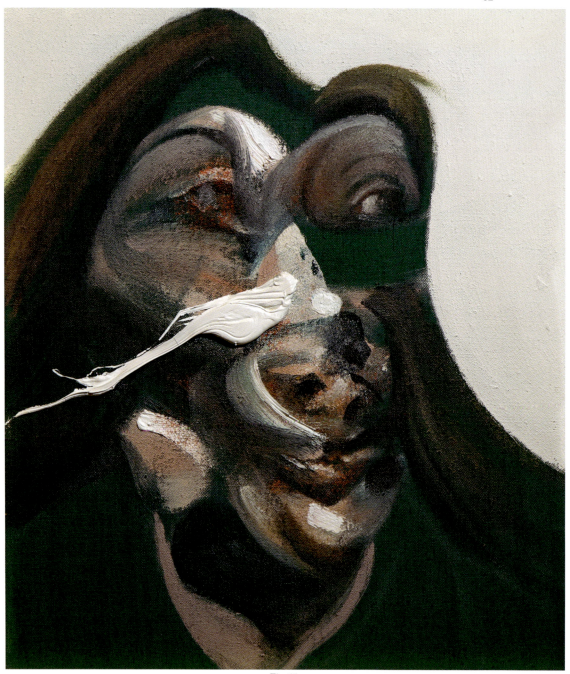

Fig. 65

Fig. 65 Francis Bacon, *Study for Head of Isabel Rawsthorne*, 1967, oil on canvas, 14 × 12 in. (35.5 × 30.5 cm), private collection, courtesy M. Ars SA

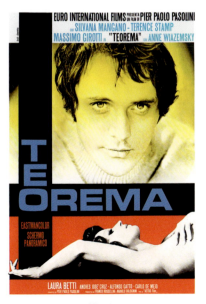

Fig. 66

Pasolini's replacement of the Lewis painting while adapting the novel to the screen appears all the more significant in that he himself emphasizes the paintings' initiatory role in the story. There are several complementary explanations for this replacement. First, Pasolini may have wanted to accentuate the scene's equivocal atmosphere through Bacon's painting of a couple making love. This would be a way of implying Pietro and the visitor's act without showing it. Second, Pasolini probably wanted to reinforce the sacred dimension of his film by showing a crucifixion and a triptych—a pictorial form borrowed from religious art. Otherwise, why make this selection, among all Bacon's works? Granted, Bacon regularly made use of triptychs, including for his portraits of Henrietta Moraes and of Lucien Freud, but they were far from his most common format. Third, for a mass-audience film, Francis Bacon, famous British painter, was a more obvious choice than Wyndham Lewis to incarnate the figure of the rebel artist, creating his works against the grain of the bourgeoisie. Not only does Bacon's tortured painting assault the conventions of so-called good taste more violently, but also his life itself was scandalous. Fourth—and finally—by using Bacon's paintings, Pasolini probably wanted to foreshadow the film's last scene, in which the father wanders screaming through a desert of ashes.

We must linger for a moment on these final, unforgettable images in *Theorem*, which are an addition to the film. In the book, Pasolini describes how Paolo, after having given his factory to the workers, abandons everything, strips naked in the middle of the Milano Centrale train station, and walks into the distance, under the wary gaze of the other travellers. The book concludes with this image. For anyone possessed of a minimum of Christian culture, this final act of abnegation obviously symbolizes the desert, the—real or symbolic—site of the tribulation that must be suffered by all who want to follow Christ. Indeed, it is in the desert—whether of spiritual

Fig. 66 Bob De Seta, *Teorema*, 1968, poster of the movie, 55 × 78½ in. (140 × 200 cm), Webphoto Collection

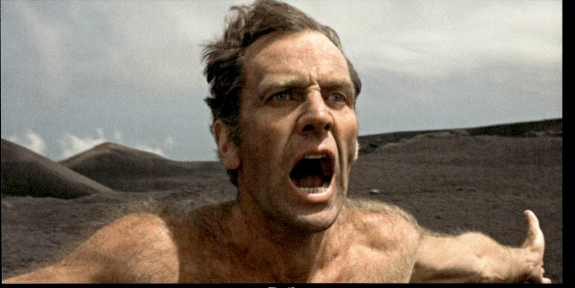
Fig. 67

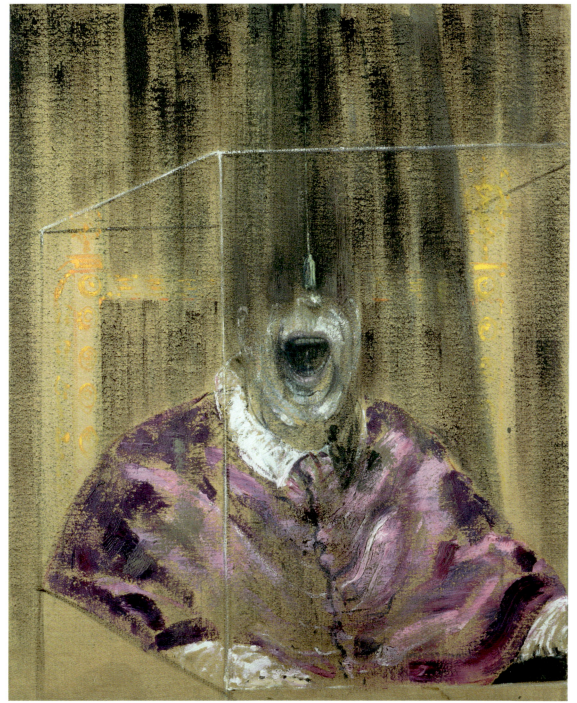

Fig. 68

Fig. 68 Francis Bacon, *Head VI*, 1949, oil on canvas, 36½ × 30 in. (93.2 × 76.5 cm), Arts Council Collection, Southbank Centre, London

barrenness or physical destitution—that the believer confirms the constancy of his faith and his desire for god.

In his film, Pasolini chose to embody on screen what in the book remained only an allegorical image. It is as if he had enacted, as a filmmaker, the exegesis of his own text, revealing its meaning to the viewer. Pasolini thus shows us the flight into the desert, rather than only implying it. As in the book, Paolo undresses in the station. The shot is framed in such a way that we see only his feet, and his clothes falling one by one at his side. Then Paolo turns around and walks away (we still see only his bare feet among the shoed feet of the travellers witnessing the scene). Suddenly, through a jump-cut that seems to indicate a shift in time but actually indicates a leap into a symbolic order, we see Paolo's feet stepping along grey sand. The shot broadens and shows him wandering, naked, in a desert of ashes. It all ends with a cry, a cry of rage and despair that echoes the cries of the pale figure in the *Fragment of a Crucifixion* and the "monster" painted by Bacon on the right

Fig. 69

Fig. 69 *Theorem*, 1968

panel of *Three Studies for Figures at the Base of a Crucifixion*. A cry that also recalls, even if only subliminally, the series of studies after Velázquez's portrait of Pope Innocent X, a series that counts among Bacon's most famous works. The cry of figuration.

Contemporary art will not save the world

While *Theorem* is akin to Pasolini's earlier films for the central role it accords to paintings, the difference here is that the paintings are contemporary. Caravaggio and Piero della Francesca have given way to Bacon. Further, painting is no longer simply used as a reference point or source of inspiration: it becomes itself a subject of discourse through the character of Pietro. After his encounter with the enigmatic guest, which acts as a revelation, Pietro embarks on what he believes is his artistic vocation. His paintings, however, are worthless and merely reveal his fundamental impotence. The irony towards contemporary art reaches a particularly mordant extreme when Pasolini shows Piero pissing on his scribblings, in the belief that he is refining the lessons of drip painting.

Pietro remains the same "bourgeois boy who is destined not to fight" that he was before his encounter with the visitor. He is still "marked by the precocious lack of any kind of unselfishness, of any purity"(*Theorem*). For him, becoming an artist merely means trading one kind of conformism for another. Pietro comes into no freedom through art; he remains a follower. He is the archetype of the poser artist, such as it emerged in the social field during the 1960s. Clearly, for Pasolini, art will not save the world. Or in any case, not this kind of contemporary art, bourgeois par excellence, which the film portrays as an aimless, pointless delusion.

This is not to say that Pasolini condemned all the art of his time as insignificant. Francis Bacon, his contemporary (Bacon was born in 1909, only thirteen years before Pasolini) is presented as a model—even if, finally, an unattainable one. What Pasolini condemned, rather (like Piero Manzoni before him), were the new art forms accompanying the rise of consumer society and mass media. In this respect, it is revelatory that Pietro is presented in *Theorem* as a follower of Jackson Pollock, a heavily publicized artist who first made his name through *LIFE* magazine in 1949, and was then introduced in Europe a decade later through a large travelling "blockbuster" exhibition organized by MoMA (in Italy, Jackson Pollock's retrospective exhibition at the Galleria Nazionale d'Arte Moderna took place in 1958). These are the artists Pasolini rails against here, the ones who abandon their painting studios for television studios, the ones who devote their talents to self-promotion and not to their work. In his eyes, these artists' false provocations are merely the flip-side of the false tolerance proclaimed by contemporary society.

The artists that Pasolini cites or offers up as examples in *Theorem*—whether Francis Bacon (in the film) or Ezra Pound (in the book)—show fairly well where he situates art. Bacon and Pound, in their respective fields, freely created new, radical forms; they created against their time. Pound, of course, was not only the author of *The Cantos*, a monumental, difficult work mixing English, French, Latin, and even Chinese; he had also, as an American avant-garde poet, lost his way as a follower of Fascism in Italy. Nevertheless, to Philippe Sollers' question, "Can we prefer a right-thinking mediocre literary bureaucrat to a wrong-thinking great artist?" Pasolini would not have hesitated to answer in favor of Pound. Better yet, Pasolini was so interested in Pound that, despite their precisely opposite political passions, he went to visit him in Venice on October 26, 1967. The brilliant encounter was documented in Vanni Ronsisvalle's film *An Hour with Ezra Pound*. Amid their conversations, as Pasolini sketches portraits of Pound, the two poets broach the topic of contemporary art. Pasolini's mention of Pound in *Theorem* (which he was writing at the time), in a chapter entirely devoted to the revelation of modern painting, is certainly no coincidence.

In any event, it is significant that Pasolini sided with Ezra Pound and Francis Bacon. Their non-conformist approaches to both art and life mirrored his own. They appear as anti-models of the new figure of the "artist" incarnated by Piero in *Theorem*. In a certain light, they recall another artist-intellectual who was close to Pasolini and was himself a lucid critic of the society of spectacle: Fabio Mauri (1926-2009).

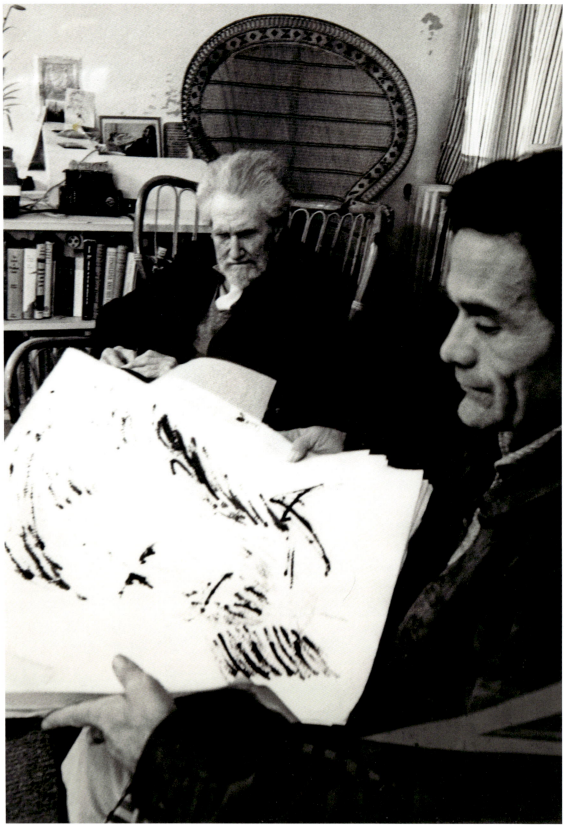
Fig. 70

Fig. 70 Vittorugo Contino, *Pier Paolo Pasolini and Ezra Pound*, 1967, silver gelatin print, 12 × 8 in. (30 × 20 cm), Vanni Ronsisvalle Collection, Rome

Fig. 71 Pier Paolo Pasolini, *Portrait of Ezra Pound*, 1967, ink on paper, 22½ × 16½ in. (57 × 42 cm), Vanni Ronsisvalle Collection, Rome

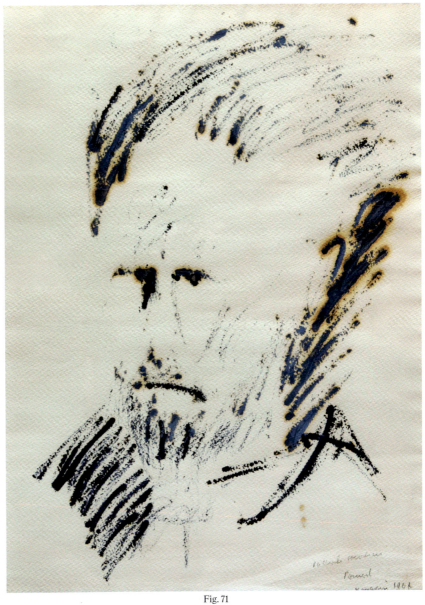

Fig. 71

II. The friendship with Fabio Mauri

As *Theorem* fairly clearly demonstrates, Pasolini had a more-or-less critical approach to contemporary art. Among the handful of artists who found favor in his eyes, the most unclassifiable one of all is Fabio Mauri. For half a century, Mauri made art on the margins of the principal movements of his time, from Arte Povera to Transavanguardia. Like Pasolini, he was an intellectual. All his works started with writing before finding a physical form. He went so far as to claim his studio was in his head, a statement confirmed by the many work notebooks kept at the Studio Fabio Mauri in Rome.

Pasolini and Fabio Mauri met when they were teenagers. In 1942, they founded a short-lived literary review together, *Il Setaccio*. Pasolini then wrote a text for one of his friend's first exhibitions, at the Galleria Aureliana in Rome. After becoming a filmmaker, he offered him parts in his films. Though Mauri declined to play John the Apostle in *The Gospel According to Matthew* (he considered himself too old to be the youngest of the apostles), he accepted the role of King Pelias, to whom Jason brings the Golden Fleece in *Medea* (1969).

Fig. 72 *Medea*, 1969

In return, Fabio Mauri invited Pasolini to participate in a performance. The result, *Intellettuale*, was staged on May 31, 1975, at the Galleria d'Arte Moderna in Bologna. As its title implies, the piece was a veritable homage to Pasolini, who at the age of fifty-three had become a world-famous intellectual. The title also refers to the performance itself, which Fabio Mauri presented as an "intellectual experience." Indeed, though the process was fairly simple (in a darkened room, Mauri projected onto his friend's chest the film *The Gospel According to Matthew*), its interpretation is complex.

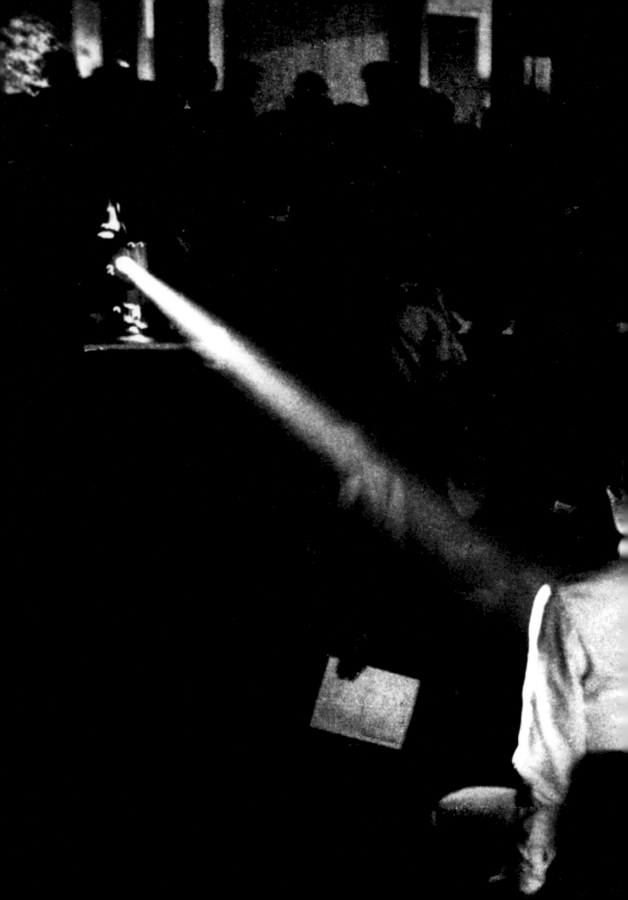

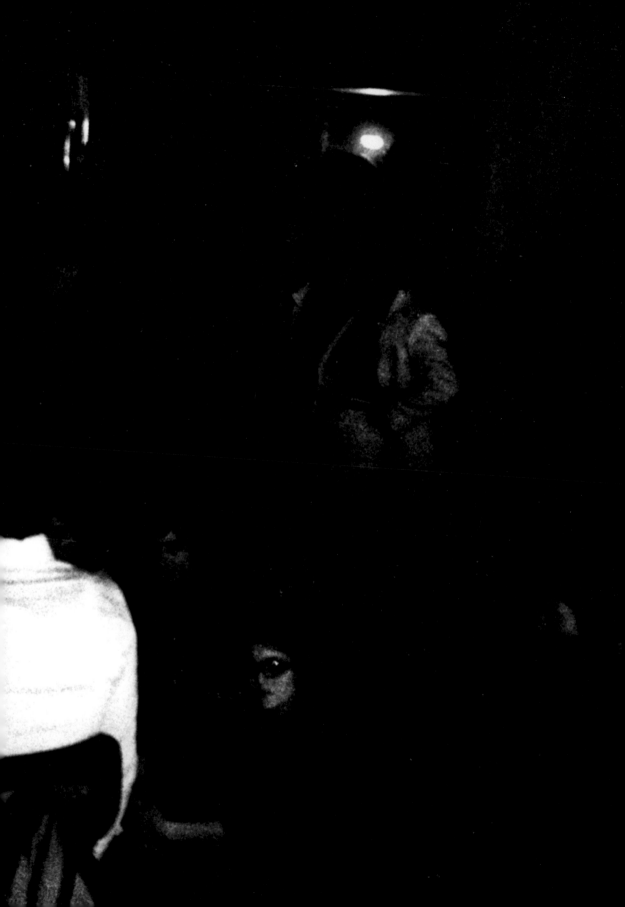

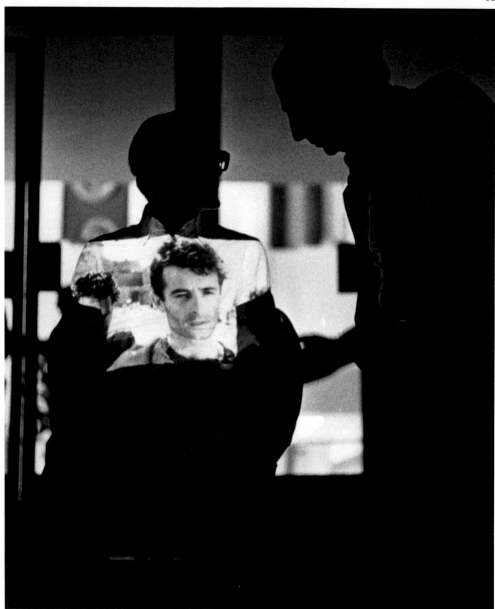

Fig. 73

Pages 94–95 and fig. 73 Fabio Mauri, *Intellettuale. Il Vangelo Secondo Matteo di/su Pier Paolo Pasolini*, 1975, silver photography, Galleria Comunale d'Arte Moderna, Bologna
Fig. 74 Fabio Mauri, *The End*, 1959, vellum paper and tempera on wood, 22½ × 22½ × 1½ in. (56.5 × 56.5 × 4.4 cm) (framed), private collection

The white cloth of Pasolini's shirt of course evokes the white canvas of a cinema screen. Pasolini thus becomes the living screen of his own film. One might see this as a way of making him bear responsibility for it, recalling the role of the intellectual-artist as a "committed spectator." To choose to tell a particular story, in a particular way, is to take a position. That was an idea Pasolini and Mauri both shared. Here, we are at the antipodes of the dandyish vision of "art for art's sake."

During a talk at Hauser & Wirth Monaco in 2022, Dominique Païni proposed an additional interpretation: in the context of the 1970s when television was threatening to replace cinema, projecting a film onto its maker was a way of proclaiming a commitment to "auteur cinema." Under this reading, the projection becomes a way of rendering unto the director his full status as an artist, at the very moment when television seemed to be stripping him of that status (how many people notice the names of TV movie directors?).

It was no accident that Fabio Mauri and Pasolini were friends. They shared the same fixation with the persuasive power of images, a power appropriated by the consumerism of an economically booming Italy. Fabio Mauri, for his part, pursued these reflections through his *Schermi*. In these works, he identifies the blank canvas of the painting with that of the cinema screen, each destined to receive images—a way of recalling that no art is entirely free of a political, or even propagandistic, dimension.

Fig. 74

The Contemporary Extreme

Fig. 75

Fabio Mauri's entire body of work is haunted by a concern: the possible coincidence of beauty and lies. This is the principal theme of his performance *Che cosa è il fascismo* (1971), which evokes the memory of the Fascist *Ludi Juvenales* celebrated at the Boboli Gardens in Florence during Hitler's visit to Italy in May 1938. Fabio Mauri and Pasolini both participated in this youth competition. At the time, Mauri was twelve and Pasolini sixteen.

Here is how Valérie Da Costa, in her beautiful essay dedicated to the artist, summarizes the performance conceived by Fabio Mauri: "Bringing real elements into the performance space, he constructed a mise-en-scène out of actual historical documents, books and records bought at

Fig. 75 Fabio Mauri, *Che cosa è il fascismo. Festa in onore del generale Ernst Von Hussel di passaggio per Roma*, 1971, video and performance, Stabilimenti Safa Palatino, Rome

second-hand shops, Fascist uniforms found in Army surplus stores. He used these clothes and also had replicas of them made. For one hour, the students, non-professional actors, were made to read extracts of Fascist propaganda texts written between 1929 and 1941, extolling the party, family, race, the body, agriculture, all accompanied by athletic events (ball games, flag parades, fencing...) such as one might have seen during these ceremonies meant to indoctrinate the Italian people."

The first performance of *Che cosa è il fascismo* took place on the evening of April 2, 1971 at the Safa Palatino cinema studios in Rome, attended by figures of the Italian intelligentsia, including Pasolini (who also came to the dress rehearsal) and his friend Alberto Moravia, whose publisher Valentino Bompiani was Fabio Mauri's uncle.

Fabio Mauri spoke of the deeper meaning of his performance on several occasions. In 1971, he wrote in a notebook: "Error links itself to something else, usually truth and beauty. The stupidity of innocent natures is the naïve accomplice of every evil." In a 1995 lecture, he described *Che cosa è il fascismo* as an evocation of the "deceit" he "saw and experienced": "That fake youth dissimulated within order, immersed in an outrageous, catastrophic lie."

Pasolini was certainly influenced by Fabio Mauri's long reflection on Fascism, and more generally the nature of evil, that had culminated in *Che cosa è il fascismo*. It is no coincidence that Pasolini dealt with the same theme a few years later in *Salò*. Fabio Mauri's warning to the viewer at the opening of his performance would be just as apt for his friend's film: "Here, you will experience in a short time the effect of ideology, the abyss of institutionalized Superficiality, the Tautology of absolute Power, and the intimate cruelty of the lie concealed behind Order."

Fig. 76 Fabio Mauri, *Pier Paolo Pasolini and Fabio Mauri at the Dress Rehearsal of* Che cosa è il fascismo, 1971, silver photograph, Stabilimenti Safa Palatino, Rome

The Contemporary Extreme

Pasolini at the Château de Silling

Villa Aldini (1811-1816)

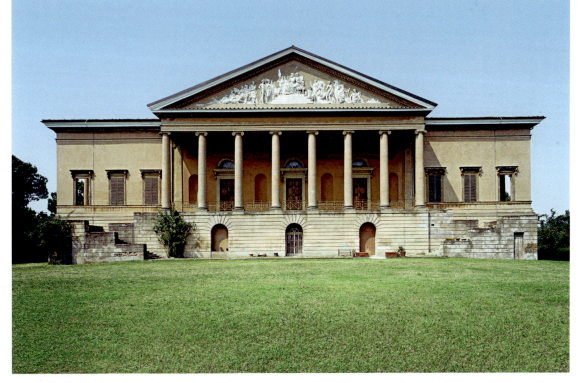

> "The Society of the Friends of Crime is not a caricature but rather a stylization of our reality."
>
> Octavio Paz

As a writer, Pasolini naturally had a close relationship with the classics, from the Greek tragedies to the *Thousand and One Nights*, *The Canterbury Tales*, and *The Decameron*. But it was his reading of Sade that most deeply marked him. How else does one explain that he wrote a study on him and dedicated the *Lutheran Letters* to the "scornful shade of the Marquis de Sade"?

Philippe Sollers once stated the problem Pasolini faced: "Sade's oeuvre is a continent; it is undoubtedly the most radical, the most irreducible thing ever produced in the history of French literature. Obviously, a film adaptation would have to be similarly radical" (*Le Monde*, August 23, 2000). This film adaptation was *Salò, or the 120 Days of Sodom*, written by Pasolini in collaboration with Franco Citti and Pupi Avati. It would be Pasolini's last film, the most disturbing, least understood of all, "a major film in any case, for its power and its allegorical oddness"(Hervé Joubert-Laurencin). When it was released in 1975, its famous author had just been murdered on the beach in Ostia, under circumstances that have never been fully explained. The violence of his death seems to echo the violence of the film. Interpretation goes awry. Reality blurs with fiction.

Should we, like Serge Daney, see this last film as "the reconstruction, in a comparable context (Italian Fascism) and similar setting (Salò), of the doomed masters' final attempt to exercise their power?" Partly, no doubt. But Pasolini's project went beyond mere adaptation. Through his film, Pasolini wanted to pass judgment on the body and the sexuality of his era and their relationship to politics. (He aligns here with Lyotard, Deleuze, Foucault, Schérer, and others, who were

bringing this question into the field of philosophy at the same moment). If, in the *Trilogy of Life*, a magnified vision of sex becomes a means of reconciling humans with each other, in *Salò* it marks their separation. Once again, Pasolini's position had completely shifted. After "abjuring" his *Trilogy of Life*, he could no longer stage desiring and desired bodies: in *Salò*, therefore, we witness their systematic destruction. To understand this radicalism (which makes the film an avant-garde work rather than a blockbuster) one must analyze it in light of the political positions adopted by Pasolini during the time he was writing and filming *Salò*. And one most also place this radicalism in relation to the fundamental radicalism of Sade's text. For on this and many other points, one cannot correctly analyze Pasolini's film without continuously returning to Sade's writings. There can be no interpretation without this back-and-forth.

Sade and the manuscript of *The 120 Days of Sodom*

Donatien Alphonse François de Sade (1740–1814) is one of the most peculiar figures in French literature. With Machiavelli, Sacher-Masoch, and Proust, he belongs to the rare number of writers who have given rise to words derived from their last name: *sadistic* (adjective); *sadist* (noun); *sadism* (noun). The dictionary *Le Robert* gives the following definition of the latter noun:

> *psychology.* Sexual perversion in which pleasure can only be derived from inflicting pain on the object of desire. *colloquial.* Perverse taste for cruelty to others.

This perverse taste would cause Sade many difficulties. As Simone de Beauvoir has speculated, it is likely Sade initially hoped he could satisfy his penchants without compromising himself. But even if he sincerely wished for this, little by little he gave himself away. "He probably wanted to emphasize the radical separation between his family life and his private pleasures; and probably, too, the only way he could find satisfaction in this clandestine triumph lay in pushing it to the point where it burst forth into the open." After a litany of scandals (Sade introduced one of his mistresses to the provincial nobility as his wife; he locked up a beggar woman in his house to thrash her and stab her all over with a penknife; he accidentally poisoned Marseille prostitutes; he seduced his young sister-in-law, a virgin nun, with whom he fled to Italy, etc.) he ended up in prison at the Château de Vincennes "locked up like a savage beast behind nineteen iron doors," as he wrote. It was during these twelve years of imprisonment—first at Vincennes, then at the Bastille—that he composed, on a narrow roll of paper 4¾ inches (12 cm) wide by 39 feet 8 inches (12.10 m) long, *The 120 Days of Sodom*. The text, through an event beyond his control, remained unfinished.

On the night of July 3, 1789, Sade, who had tried to rile up the mob gathered at the walls of the Bastille using a makeshift megaphone, was transferred to the Hospice de Charenton. Taken away "naked as a worm," he had to abandon his belongings, including the manuscript of *The 120 Days of Sodom* that he believed lost forever after the storming of the Bastille on July 14, 1789. In fact, the manuscript was found in his cell by a certain Arnoux de Saint-Maximin and then passed into the hands of the Villeneuve-Trans family, who kept it for three generations. In the late-nineteenth century, it was sold to a Berlin psychiatrist, Iwan Bloch, who under the pseudonym of Eugène Dühren published a first version of the text in 1904—in a very limited edition containing many transcription errors. It was nevertheless thanks to this first publication that Proust and the Surrealists discovered *The 120 Days*. The manuscript was then put up for sale.

Luis Buñuel writes in his memoirs, "I held in hand the original manuscript of *The 120 Days of Sodom* and even nearly bought it. It was the Vicomte de Noailles who got it finally—a fairly large scroll." This was in 1929, when the renowned art patrons Charles and Marie-Laure de Noailles—the latter was a descendant of the Marquis de Sade—commissioned Maurice Heine to buy back the manuscript. Heine edited it with rigor and published it (in an edition of 360 copies) between 1931 and 1935. *The 120 Days of Sodom* was saved for good.

Sade and the twentieth century

The discovery of *The 120 Days of Sodom* took place amid a general renewal of interest in Sade's prolific work. In the remarkable book *The Romantic Agony: Flesh, Death, and the Devil*, Mario Praz reminds readers that Sade was "a hidden force of the Romantic Movement, a familiar spirit whispering in the ear of the 'mauvais maîtres' and the 'poètes maudits.'" Sade's influence, nevertheless, had remained marginal. Everything changed at the beginning of the twentieth century. As Éric Marty points out, Sade was suddenly taken seriously—especially by the literary and artistic avant-garde.

The review *Documents*, financed by the art dealer Georges Wildenstein and co-directed by Georges Henri Rivière, Carl Einstein, and Georges Bataille, played a key role in this renewal. Fifteen issues were published between April 1929 and January 1931, with several focusing on Sade. Michel Leiris

Fig. 77 *Documents 7*, December 1929, printed journal, 10½ × 8½ in. (27 × 21.7 cm), Francis Bacon MB Art Foundation / MB Art Collection
Fig. 78 Photograph of the original autograph manuscript of *The 120 Days of Sodom*, written by the Marquis de Sade at the Bastille in 1785, photograph by Jacques-André Boiffard published in *Documents 7*, December 1929, Francis Bacon MB Art Foundation / MB Art Collection

Fig. 77

(who was about to join the review as its secretary) noted on June 30, 1929, in his *Journal*: "Rivière is the only man I know who can give one the impression that he has truly signed a pact with the devil. In his presence, I think of three characters: Dolmancé in *Philosophy in the Boudoir*, *Un Allemand* [Felix Paul Greve] described by André Gide, and Kurtz from Joseph Conrad's *Heart of Darkness*. It is quite normal that such a man should have been the close friend of Jouhandeau and, currently, of Bataille." With such a director, it is no surprise that issue seven of *Documents* devoted two long articles to Sade and reproduced several of his manuscripts, including the famous scroll of *The 120 Days of Sodom*, photographed by Jacques-André Boiffard.

Fig. 78

Sade, during that period, was at the heart of a quarrel between Bataille (a dissident Surrealist) and Breton. Bataille's article "The Language of Flowers," published in June 1929 in the third issue of *Documents* and concluding with the image of "the Marquis de Sade, locked up with madmen, who had the most beautiful roses brought to him only to pluck off their petals and toss them into a ditch filled with liquid manure," was violently attacked by Breton in his *Second Manifesto of Surrealism* (1930), pre-published on December 15, 1929, in the twelfth issue of *La Revolution Surrealist*. Sade's fame was assured—for the duration.

Since then, Sade's works have been the subject of constant attention from artists and writers. Here, in chronological order, are a few significant examples: 1930, Luis Buñuel's *L'Âge d'Or*; 1937, Paul Éluard's *Les Mains Libres* (Free Hands) with illustrations by Man Ray (whom Pasolini would keep company with in the 1970s, as shown by a photo from a holiday in Fregene held at the Archive Carol Rama); 1938, Man Ray's *Imaginary Portrait of D.A.F. de Sade*; 1947, Pierre Klossowski's

Sade My Neighbor: The Philosopher Villain (Klossowski was close to the Surrealists, particularly to Bataille whom he met in 1934); 1949, Maurice Blanchot's *Lautréamont and Sade*; 1950, Maurice Heine's *Le Marquis de Sade* (posthumously published); 1952, Gilbert Lely's *Vie du Marquis de Sade* (a biography republished in an expanded version in 1982); 1953, Simone de Beauvoir's *Must We Burn de Sade?*; 1960, Octavio Paz's *An Erotic Beyond: Sade*; 1968, Philippe Sollers' *Writing and the Experience of Limits*; 1971, Roland Barthes' *Sade, Fourier, Loyola*.

When Pasolini set himself to Sade's work, it was already well known. Fashionable, one might even say. He was probably spurred on by the commentaries about it. Perhaps a kind of

Fig. 79

Fig. 79 Man Ray, *Imaginary Portrait of the Marquis de Sade*, 1938, oil on canvas with painted wood panel, 24 × 18½ in. (61.6 × 46.7 cm), The Menil Collection, Houston
Fig. 80 Paul Eluard, Man Ray, *Les Mains Libres*, 1937, original edition, typographical printing and lithograph, Chancellerie des universités de Paris—Bibliothèque littéraire Jacques Doucet

Fig. 80

identification was even at play. For Sade and Pasolini share a number of biographical traits: they were both polemicists who had scrapes with the law. They both wrote for, and against, their time. Sade joined forces with the French Revolution (he was a member of the Section des Piques, the same revolutionary section as Robespierre) before falling victim to it, just as Pasolini enrolled as a member of the Italian Communist Party before being expelled for "bourgeois degeneracy." They even had certain aspects of their eroticism in common. As René de Ceccatty remarks, there are "innumerable stories of phallolatry in Sade" that find an echo in chapter 55 of *Petrolio*. The chapter, entitled "The field beside Via Casilini," consists of "twenty sexual encounters, with fellatio and sodomy, all on the same model, which is to say that Carlo entirely submits to the phallus of his partners."

Pages 112–113: Christopher Makos, *Man Ray, Luciano Anselmino, Pier Paolo Pasolini, Piergiorgio Marin, and Juliet (Man Ray's Wife)*, silver photography, Fondazione Sardi per l'Arte / Archivio Carol Rama, Turin

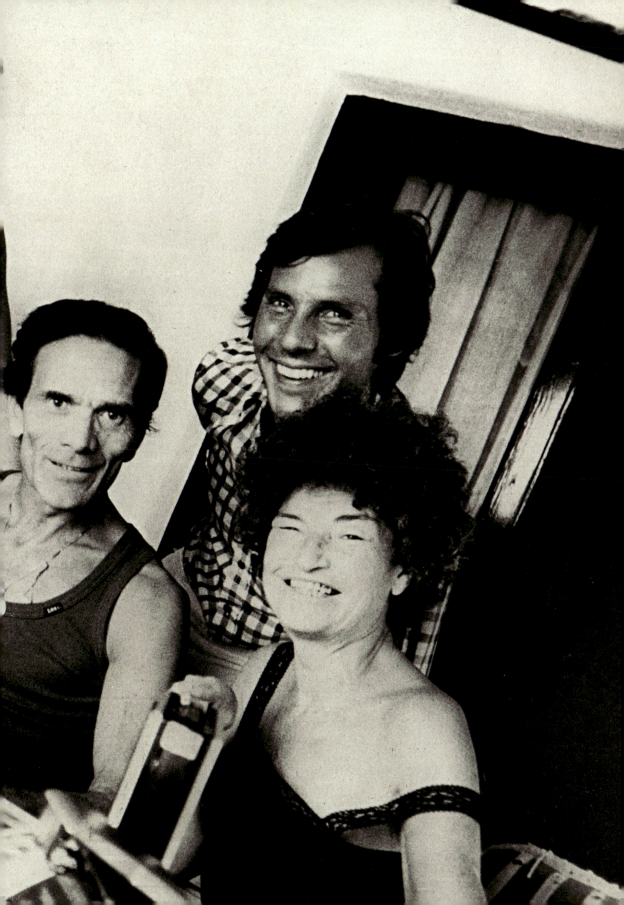

Summary of a summary

With the context established, we should now try to summarize *The 120 Days of Sodom*, since it is this particular text that Pasolini chose to transpose to film. Sade sets his story toward the end of the reign of Louis XIV, or the early eighteenth century. Four men, immensely rich, between the ages of forty-five and sixty, the Duc de Blangis, his brother the Bishop, the President de Curval, and the banker Durcet, sequester themselves for the winter in the Château de Silling, an unreachable fortress at the heart of the Black Forest, with forty-two victims: the four men's wives (each has wed the daughter of the other) and young boys and girls abducted from their parents. Four procuress "historiennes" are also there, who take turns from month to month telling the story of 600 perversions (150 each) that are often put into practice on the spot by the masters of the chateau. The victims are abused, tortured, and murdered.

The book, in the form of a journal, is composed of four parts (the first is complete, the others were left as mere outlines) each corresponding to one of the four months and to "simple," "double," "criminal," and "murderous" passions, respectively. Their description is interwoven with the events of the chateau.

For Sade in general, and *The 120 Days of Sodom* in particular, pleasure involves neither generosity nor reciprocity. It is a matter of pure egotism, of cruelty, if not crime. In Sade's words, "What would pleasure be, if it were not accompanied by crime?" As Simone de Beauvoir summarizes it, "the supreme intention that quickens all sexual activity is the will to criminality. Whether through cruelty or befoulment, the aim is to attain evil." This intention, at Sade's moments of extreme exaltation, aims for the apocalypse: "to attack the sun, to deprive the universe of it, and use it to set the world ablaze—those would be crimes indeed!"

An impossible representation?

One understands, in such a context, why adapting Sade to film has often been considered a hazardous enterprise. Chantal Thomas says as much in the preface to her book *Sade, la dissertation et l'orgie*, "All in all, I find every attempt to represent Sade's work painful. It destroys the margin of silence and secrecy—of fear as well (fear of ourselves, fear of the enigma we are to ourselves)—that necessarily shadows our reading.

This may be what Guy Debord meant to indicate by his 1952 film *Howlings in Favor of de Sade*, which, in spite of its title, contains not a single direct reference to Sade. The film is a succession of white and black screens, accompanied by voice-over dialogues. The absence of images plausibly evokes the irrepresentability of a text like *The 120 Days of Sodom*.

Michel Foucault, for his part, declared in an interview with the magazine *Cinématographe* (December 1975), "There's nothing more allergic to film than the work of Sade. Among the many reasons for this, there is this one to begin with: the meticulousness, the ritual, the rigorous forms of ceremony that you find in all of Sade's work excludes anything that the supplementary play of the camera might contribute. [...] The moment anything goes missing or is superimposed, all is lost. [...] Trying to adapt Sade, this meticulous anatomist, into precise images doesn't work."

Alain Fleischer, too, evoked the impossibility of representing Sade's work in an interview with Jacques Henric in 2013. The same year, Fleischer published a long text *Sade Scénario* (Sade Script), whose composition spans several decades. The book is a film project about Sade himself rather than his novels—the only way out, according to Fleischer. For him, Sade's biography has the potential to "become script" while his "most extreme works" are "not destined for film." Fleischer writes that Sade's literature is "the work least suited to being adapted to film." Why, we might ask? "The Sadean scene doesn't move." Sade's novels "seem like paintings in the static horror of their situations." (A fact already noted by Roland Barthes: "The Sadean group is often a pictorial or sculptural object: the discourse captures the figures of debauchery not only as arranged, architectured, but above all as frozen, framed, lighted, it treats them as tableaux vivants.") It is certainly true that Sade's scenes are static, but couldn't Pasolini have been attracted precisely to this presence of tableaux vivants at the heart of Sadean narrative? Where Alain Fleischer perceives a limit, didn't Pasolini on the contrary see yet another stimulus? Since his earliest films, Pasolini had not only taken inspiration from classical painting but also made use of the uncommon practice of tableaux vivants.

Regardless, if such brilliant writers as Chantal Thomas, Michel Foucault, and Alain Fleischer all more or less agree, then there must be something irrepresentable about Sade's text. One might call this thing "hyperbolic horror." *The 120 Days of Sodom* attains such hyperbolic horror during the description

of the torture of Augustine: her torturers flay her alive, quarter her, pierce her throat and pull her tongue through, cut her ears off, burn her eyes, scalp her, before having their pleasure with her in that state and opening her to burn her entrails and stab her heart from within, scalpel in hand.

What director, confronted with such a scene, wouldn't fall short of Sadean excess? One indeed finds here an "impossibility to approach, through figurative means, the degree of violence with which the written text assaults the bodies"(Alberto Brodesco). In other words, Sade's text poses a problem of verisimilitude, not only for horror but also for pleasure. Barthes grasped this when he observed, "the complexity of combinations, contortions of partners, potency of ejaculations and endurance of victims—everything is beyond human nature."

While the idea of the irrepresentability of Sade's work is tempting enough to have been often invoked, it is nevertheless proved false by actual fact. Over the course of ten years, between 1967 and 1977, no less than eighteen films inspired by or adapted from Sade were made. The encounter between Sade and cinema even began under the most favorable light, considering it was with Luis Buñuel's *L'Âge d'Or*. Instead of declaring Sade irrepresentable, therefore, it seems more precise to say that Sadean cinema tests the limits of representation. For, at its root, Foucault's claim is not that it is impossible to adapt Sade, but rather that it is impossible to do so *faithfully*. Every filmmaker who wants to confront Sade must grapple with this inevitable gap between text and image. That is clearly what Pasolini did, when he chose to assert and even accentuate this gap by transposing Sade's universe instead of trying to reconstruct it.

Transposition rather than reconstruction

Pasolini understood that a reconstitution of Sade's novel was impossible, as it would have come up against the problem of verisimilitude. As both a writer and a filmmaker, he was well placed to know that the question of a film's "faithfulness" to the original is not a very relevant criterion for judging the relationship between film and literature. Pasolini therefore intentionally opted for transposition. The story of *Salò* is not set in Ancien Regime France but rather in Italy near the end of WWII. In other words, Pasolini is interpreting. This insistence upon interpretation is flaunted right from the beginning of the

film. Paradoxically, in a unique instance in the history of cinema, *Salò*'s opening credits include a bibliography! The works cited are by Roland Barthes, Simone de Beauvoir, Pierre Klossowski, Maurice Blanchot, and Philippe Sollers. Pasolini indicates, in no uncertain terms, that he reads Sade's work though the history of its interpretation. The film will be based just as much on commentaries of Sade's writings as on the writings themselves.

Pasolini enriched Sade's text with the commentaries of these five French writers to reveal its contemporaneity. In 1975, Barthes and Sollers were at the forefront of their time. Pasolini was not interested in Sade in his own era (or else he would have made a costume drama), nor was he really interested in historical Fascism. What he wanted to show, through this transposition, is how Sade's text sheds light on the contemporary age. And that is indeed how *Salò* was received at the moment of its release. In a 1976 interview, Marcelin Pleynet said, "I think Pasolini made use of Sade the same the same way he made use of the Gospels: he uses a cultural commonplace to convey what he has to say. It serves as a pretext. What Pasolini shows isn't the eighteenth century, it's the misery and mediocrity of the twentieth century."

But if Pasolini wanted to shed light on his own times (the 1970s) through Sade's work and its interpretations, then why transpose *The 120 Days of Sodom* to Mussolini's Italy? Why not set the action directly in the 1970s? The choice of the 1940s might seem even less apt in that the Fascists, unlike the libertines, generally trumpeted moral order. Didn't the Fascists align themselves, "not only outwardly, but also inwardly, with the rigorists and the prudes," as René Schérer writes? The explanation for this undoubtedly lies in the fact that Pasolini did not choose just any moment of Fascism but rather the moment of its fall, 1943–1944. This was "the moment of the abyss, when Fascism took the form of apocalyptic anarchy, which is its true form, exposure and destruction," as Éric Marty writes. Detached from all link to reality, distilled to its essence by the knowledge of the impending defeat, the Fascism of the last moments of the Republic of Salò fully unveiled itself. It stands as an archetype, revealing the workings of power in the society of the 1940s and of the 1970s. *Salò* is fundamentally a film about power, a political film.

The role of academicism

While the decision to transpose and interpret Sade spared Pasolini from an impossible representation, it did not spare him from the problem of fidelity as such. Can one adapt Sade to film without keeping something of its violence? What would remain of *The 120 Days of Sodom* without the torture scenes? But if they have to be shown, then how? Pasolini's answer came through academicism. Only such formal rigor could confront the horror. Unlike Roman Polanski, who drew inspiration for *Tess* (1979) from the paintings of the English Romantics, Pasolini once again chose to follow the composition lessons of the classical painters. In doing so, he remained profoundly faithful to Sade, in whose writings, as Barthes once said, "pornographic messages are embodied in sentences so pure they might be used as grammatical models"(*The Pleasure of the Text*).

 In spite of his subject, Pasolini does not resort to gore techniques such as extreme close-ups, torrents of blood, etc. On the contrary, he favors static long shots. *Salò*'s entire mise-en-scène is marked by a sense of balance and measure. Pasolini himself declared this to be his intention: "Formally, I want this film to be like crystal and not magmatic, chaotic, inventive, and out-of-proportion like my previous ones." A crystalline mise-en-scène, without effects. In *Salò*, Pasolini comes exquisitely close to the definition of cinema he offered in the short autobiographical poem "Poet of Ashes": cinema as the "language of the not-I," an impersonal language.

An eye for an eye

It is no exaggeration to say that *Salò* is an austere film. If many of the situations are obscene, the film's images never are. At no point does Pasolini abandon his fixed purpose of distancing. Accordingly, the torture scenes at the end of the film are shown from the perspective of one of the libertines watching them through a closed window. We see the executions from afar, through the binoculars' limited field-of-vision, with the image further obscured by the window frames and the lines of a grate... No sound reaches us from the inner courtyard: the scene is silent. Here, the obscenity lies above all in the fact that our gaze merges with the voyeuristic gaze of the criminal libertine. "We see through the same highly subjective framing as the libertine; even the section of space is identical: the binoculars limit his field of vision the same as ours," writes Alberto Brodesco. A viewer is never completely innocent, since a viewer participates in what he sees. Hervé Joubert-Laurencin, in his essay on the film, even goes so far as to write of "imposed voyeurism." During this torture scene, "cinema reduces itself to a scopic ritualization of horror." The viewers are confronted with the most disturbing elements of the voyeuristic urge.

The imposed voyeurism of *Salò* is a consequence of Pasolini's abjuration of the *Trilogy of Life*. This abjuration took place in a still-famous article published in the *Corriere della Sera* on November 9, 1975 (and later collected in *Lutheran Letters*). Irritated by his trilogy's commercial success (with more than 11 million tickets sold, *The Decameron* remains one of the greatest Italian box-office hits of all time, a success largely founded on a hedonistic voyeurism that runs counter to the very spirit in which the films were made), Pasolini decided to create a film that is difficult, if not intolerable, to watch. *Salò* negates the *Trilogy of Life*. In this respect, one might see a parallel between Pasolini's approach and that of Sade. As Octavio Paz aptly observed, "Sade denies God, morality, societies, mankind, nature. He denies himself and disappears behind his gargantuan negation"(*An Erotic Beyond: Sade*).

Beyond cinema

Salò posed a twofold threat: to the viewer and to Pasolini himself. But isn't that the nature of art, and the only way to make a film? Jean-Luc Godard says as much in *Histoire(s) du Cinéma* (1988–1998): "True violence is the work of the spirit. Every creative act contains a real threat for the person who dares to do it. This is how art moves the viewer or reader. If thought refuses to do violence, it exposes itself in vain to all the brutalities that its absence released." These few sentences, spoken by Godard himself, are the voice-over to a sequence of three brief shots: the first, taken from a pornographic film, shows a man penetrating a woman while another licks him from behind; the second, an extract of Tod Browning's *Freaks* (1932), shows a microcephalic man seated at a table and laughing; the third shows the naked corpse of a women dragged by her arms in a concentration camp. Faced with an excess of representation, the viewer wavers between fascination and disgust. Such images simultaneously attract and repel the eye. They are an unveiling, the transgressive nature of which staggers us, leaves us without a will, unable to look away, in a state that Pascal Quignard masterfully analyzed in *Sex and Terror*. The status of such images—and, therefore, the distinction between fiction and reality—plays a fundamental role in their reception. Watching archive images of the Holocaust is not the same thing as watching *Schindler's List* (1993). Pasolini, however, abolishes this distance by rejecting the codes of fiction and adopting those of documentary (an objective gaze, an absence of mise-en-scène). In doing so, he accords with Foucault's intuition that Sade's work "excludes anything that the supplementary play of the camera might contribute."

By adapting Sade, Pasolini shattered the usual categories of cinema. The brutal, indexical truth of the acted gestures creates an uneasiness, intentionally accentuated by the casting: by choosing unknown actors, Pasolini further blurred the boundary between fiction and documentary. He also intentionally retained details that betray the film-making process and reveal the real discomfort of the young actors (the victims), who were not professionals, as they entered into their roles. At times we see an embarrassed smile, or a brief glance at the camera that Pasolini chose to keep in the final edit. "The young actors in *Salò* seem forced to accept their abjuration of innocence," as Alberto Brodesco writes.

Fig. 81 *Salò, or the 120 Days of Sodom*, 1975

Cinema here approaches Pasolini's definition: "the written language of reality."

From this perspective, we might readily agree with Hervé Joubert-Laurencin's characterization of *Salò* and of Pasolini himself: "a 'multimedia' artist before his time in the century of the avant-gardes and of Marcel Duchamp, Pasolini has occasionally been considered closer to a contemporary performance artist than a traditional poet or classical filmmaker. In this sense *Salò* cannot be limited to its designation as a *film*: it is also, and only still more so in the twentieth century, a work of contemporary art, going beyond cinema."

The scene of the crime

But let us return to Sade's novel. In *The 120 Days of Sodom*, the four libertines sequester themselves with their harem in the Château de Silling, in the depths of the Black Forest. This château is a Sadean scene par excellence. Besides symbolizing the claims and privileges of the nobility, it is isolated from the world, inaccessible: the bridge leading up to it has been destroyed and the entrance door walled up by the master of the house. As Roland Barthes points out, this enclosure founds an autarky. Once immured, the four libertines, their assistants, and their victims form a complete society subject to its own rules. And, indeed, Sade's negative anthropology could only deploy itself behind thick walls. The libertines' criminal authority would be curtailed by any society that recognizes human rights. As Alberto Brodesco succinctly phrased it, "the libertine's liberty is based upon their isolation."

Pasolini's decision to transpose Sade's novel to the Republic of Salò is fully justified in this perspective.

Fig. 81

The Republic of Salò, which lasted from September 1943 to May 1945, was not the triumphant Fascism of the pre-war years. On the contrary, having been militarily imposed by the Nazis upon a nearly defeated Italy, it was "the enclosed (and therefore Sadean) space of a ridiculous excess of legislation, of regulations, a madness of mise-en-scène," as Serge Daney writes. It offers a satisfactory historical equivalent to the autarkic chateau fantasized by Sade.

Pasolini situates the action of his film right from the opening shot, with a view of the city of Salò (indicated by a road sign), on the western shores of Lake Garda. He specifies the time period in the next shot, by including the back of a military truck and two Wehrmacht soldiers. This can only be the Republic of Salò.

Pasolini then introduces the four distinguished libertines (a duke, a banker, a judge, and a bishop), seated at a table and affixing their signatures to the regulations of the villa in which they are about to lock themselves up with their victims. The medieval Château de Silling of *The 120 Days* has been replaced by an imposing neo-classical villa, better suited to the new setting. Its cold, rational lines (with colonnade and tympanum) certainly contributed to Pasolini's choice. This is the Villa Aldini, which overlooks Bologna. In the film, Pasolini "shifts" it slightly farther south, to Marzabotto (indicated, once again, by a road sign), a symbolic choice since this is where Major Reder's Waffen-SS committed war crimes against civilians in September-October 1944.

The villa in which the four libertines entrench themselves with their assistants and victims is decorated with Cubist and Futurist paintings. They are by Juan Gris, Mario Sironi, Giacomo Balla, Gino Severini, Carlo Carrà. The decoration of a boudoir, meanwhile, seems to be the work of Fernand Léger. We recognize his *Bather* of 1931, a painting that exists in several versions.

Fig. 82 *Salò, or the 120 Days of Sodom*, 1975

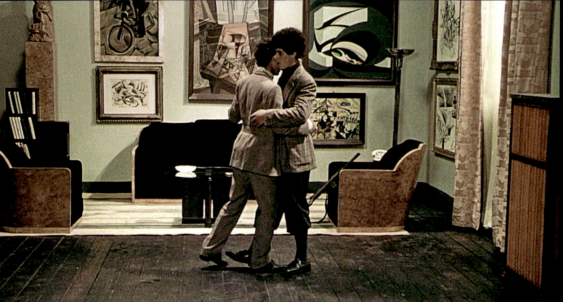

Fig. 82

Fig. 83 Mario Sironi, *Il Ciclista*, 1916–1920, oil, collage, and pencil on cardboard, 30 × 26 in. (76 × 66 cm), private collection, Rome
Fig. 84 Carlo Carrà, *Atmospheric Swirls—A Bursting Shell*, 1914, ink, collage, and charcoal on paper, 10½ × 14½ in. (26.6 × 37.2 cm), Estorick Collection, London

Fig. 83

Fig. 84

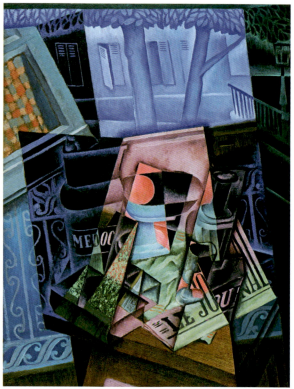

Fig. 85

Fig. 85 Juan Gris, *Still Life Before an Open Window*, 1915, oil on canvas, 45½ × 35 in. (115.9 × 88.9 cm), Philadelphia Museum of Art: The Louise and Walter Arensberg Collection, 1950

Fig. 86 Giacomo Balla, *Dimostrazione Interventista—Bandiere all'Altare della Patria*, 1915, oil on canvas, 39½ × 39½ in. (100 × 100 cm), Galleria Nazionale d'Arte Moderna e Contemporanea, Rome
Fig. 87 Gino Severini, *The North-South,* 1912, oil on canvas, 19½ × 25 in. (49 × 64 cm), Pinacoteca di Brera, Milan

Fig. 86

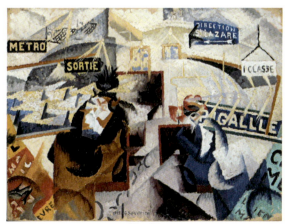

Fig. 87

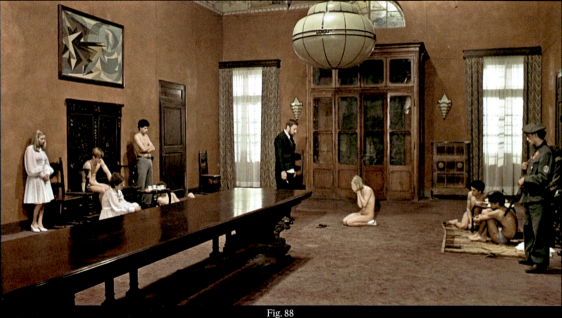
Fig. 88

Fig. 89 Giacomo Balla, *Pessimismo e Ottimismo*, 1923, oil on canvas, 45½ × 69½ in. (115 × 176 cm), Galleria Nazionale d'Arte Moderna e Contemporanea, Rome

Fig. 89

The presence of these paintings on the villa walls has two functions. Historically, it evokes the plunder of Jewish property, particularly works of art, which Hermann Göring, who considered himself an aesthete, had made into his specialty. Here, Pasolini follows Sade's text to the letter, as it tells us that the "immense fortune" of the four libertines is the "the product of murder and graft." The paintings' second, more important, function is symbolic. Their omnipresence in the film (they are constantly in the camera frame) allows Pasolini to signify that the four distinguished villains think of themselves as resolutely modern. By their spuriously dandyish refinement (they in fact pay no attention to the masterpieces all around them), they have separated themselves from the traditional peasant world and its innocence. Here, against the backdrop of a nostalgia for a mostly fantasized vision of archaic Italy, Pasolini takes up the Faustian theme of the corrupting influence of culture—without our knowing just how far it extends. Does it only apply to the masters of the villa and, through them, to all those who snobbishly pride themselves on being cultivated? Or does it extend to the artists themselves?

Ezra Pound

The Fascist setting and its dubious modern atmosphere are reaffirmed by a detail: the four libertines listen to an Italian state radio broadcast that plays the German composer Carl Orff's *Carmina Burana*, followed by a fragment of *The Cantos* of Ezra Pound. The latter choice is particularly interesting.

First of all, it must be said that the event is historically plausible, since Pound, American avant-garde poet, did indeed work for Italian Fascist radio during WWII. Between 1942 and 1943, he delivered 120 radio-broadcasts, often antisemitic and anti–Allied powers, which would lead to his becoming one of eight Americans residing in Europe to be indicted for treason at war's end. And yet it is not one of those diatribes that Pasolini chooses to have us hear, but rather twelve particularly hermetic lines of Canto XCIX. The passage's theme itself seems unrelated to the situation, or even downright irrelevant, as it consists of a summary of Confucian instructions delivered by the Yongzheng Emperor.
We understand, therefore, that Pound's presence (through his poetic works) does not merely serve a historical function. It also allows Pasolini to construct a very subtle play of mirrors

between Pound and *The Cantos* on the one hand, and *Salò* and Pasolini himself on the other.

Pound's belief in a "potential social restoration against the forces of the mercantile order and its American incarnation"(Sollers), which runs throughout his entire work, even the most polemical passages, seems uncannily similar to Pasolini's obsession with "the ideal, unresolved relationship between the plebeian, barbaric, sub-proletariat world and the rational, secular, modern [i.e. capitalist] world"(Giorgio Passerone). Strikingly, one finds in both men's poetry the same juvenile love for a pre-industrial, agrarian, artisanal Italy. Pound's and Pasolini's positions toward capitalism are equally critical. Although they were on opposite sides politically, the two men seemed to share a lineage.

To try to understand Pasolini's relationship to Pound, one has to go back to Vanni Ronsisvalle's beautiful documentary *An Hour with Ezra Pound*. Their encounter in autumn 1967, documented in the film, was that of a middle-aged man (Pasolini was 45) paying a visit to an old master (Pound was 82). In spite of his fame, Pasolini shows humility toward the elder Pound, who had completed the immense cycle of *The Cantos* the previous year. Pasolini almost seems to apologize for his visit. "'Oh let an old man rest,' you wrote at the end of Canto LXXXIII," he says. (Since his return to Venice in 1961, Pound had not delivered a single speech or said a word to the media. This meeting was therefore exceptional.) Pasolini then makes a surprising declaration—unlike any he ever made to another author—by twisting the words one of Pound's early poems: "I make a pact with you, Ezra Pound— / I have detested you long enough. / I come to you as a grown child / Who has had a pig-headed father; / I am old enough now to make friends. / It was you that carved, / Now is a time to break new wood. / We have one sap and one root— / Let there be relations between us." Pasolini, using Pound's own words, thus pardons him for his Fascist collaboration, at the same time as he establishes a shared lineage between them. Sitting opposite, almost immobile, Pound assents, "*Pax tibi pax mundi...*" And so a conversation between the two poets begins, Pound, hieratic, replying without haste, in brief, chiseled phrases prepared in advanced. Pasolini easily gets him to admit his scepticism towards the idea of Italy's industrialization as a sign of cultural progress. For Pound, as for Pasolini, industrialization and culture do not go hand in hand—quite the contrary. The four

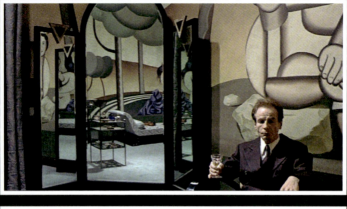
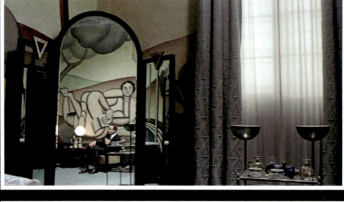

Figs. 90, 91, 92

Figs. 90, 91, 92 *Salò, or the 120 Days of Sodom*, 1975
Fig. 93 Fernand Léger, *The Bather*, 1931, oil on canvas, 38 × 51 in. (97 × 130 cm)

131

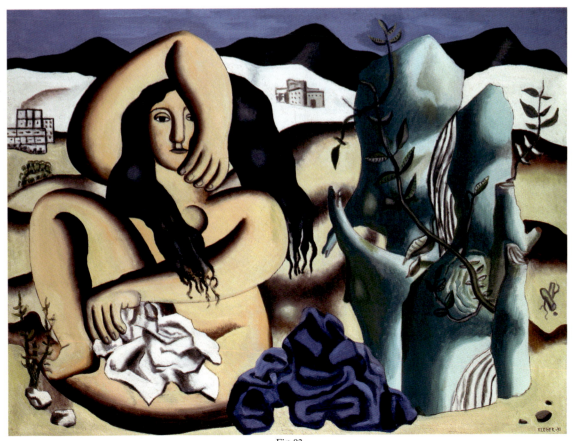

Fig. 93

distinguished Fascists listening to Canto XCIX on the radio are an exemplification of this: no matter how "modern" they are, no matter how often they quote Baudelaire or how many works of art they surround themselves with, they remain strangers to the authentically refined form of culture espoused by Pound and Pasolini alike: Humanism.

Here as well, the two poets are in agreement. When Pasolini asks Pound what painters he likes best, Pound replies he likes the Quattrocento painters, an opinion Pasolini himself, a great admirer of Piero della Francesca, could easily share. What follows of the conversation is equally revelatory. Pasolini asks again, "And among the contemporary painters?" After thinking for a moment, Pound utters a single name, "Léger." Fernand Léger, who Pasolini himself chose to include among the works adorning the four Fascists' villa... Fernand Léger, figurehead of Modernism and member of the Communist party—or in other words, the exact opposite of the four far-right would-be dandies.

The example of these few lines from *The Cantos* included in *Salò* sheds light on Pasolini's approach to filmmaking. His films are always the result of long reflection, significant work to interweave references, and an exquisite attention to detail. As a filmmaker, Pasolini remains above all an intellectual whose films always point beyond immediate appearances. This is particularly true of *Salò*, a film that is unpleasant in many respects, but has an uncommon conceptual density.

Silent teenagers and blasé torturers

Back to Sade. In Sade's novels, youth, in all its innocence and beauty, has a negative value. Accordingly, the victims are almost always young, and the libertines are old. In the world of Sade, the figure of a young libertine is inconceivable. You are not born a libertine but become one, by conquering one repugnance after another. In *The 120 Days of Sodom*, this age difference between the libertines and their victims is accompanied by a difference in the way they are described. While Sade, as Roland Barthes noted, paints realistic portraits of the libertines that "painstakingly individualize their model, from the face to sexual organs," the portraits of the victims are purely rhetorical, with the unreality of literary formulas. Sade writes that one victim is "fit for painting" and that another has "the form of Minerva with the charms of Venus." These are empty descriptions that characterize very little; they do not

make visible; they content themselves with asserting anatomical perfection. Ugliness is describable, beauty is stated, Barthes concludes.

Like Sade, Pasolini does not to give depth to the characters of the victims. In his film, they are all surface. They appear before us, young, beautiful, and resigned. They hardly speak. Was it necessary to have this silence, which leaves us in ignorance of their thoughts, in order to give us access to their despair?

If Pasolini does not develop the characters of the teenagers, it is because their function is largely symbolic. At Marzabotto, there are sixteen of them (four times four) selected for their beauty in order to be humiliated and tortured for four months by four distinguished libertines, with the help of four soldiers and four assistants. "Four: the Sadean number," Pasolini notes in the *Lutheran Letters*. The obsessive presence of the number four reflects the notion of an underlying order (reinforced by the mise-en-scène): Order as a condition of excess. Pasolini aligns here with Adorno's intuition that Fascism "made a fetish of organization as such." In the *Corsair Writings*, we find a note on "order as a purely autonomous concept." While the four dignitaries occasionally transgress this order—they themselves say they are "the only true anarchists"—they do so in affirmation of what Slavoj Zizek calls the obscene supplement of power.

From this perspective, the four dignitaries are typically postmodern: they have understood that the days of the grand ideologies are over, and they are amused to find the masses still put faith in them. The inferiority of the masses is even founded upon this very need to believe in something. Meanwhile, the four libertines, being absolutely apathetic, are free of all illusions, all dreams. We have already noted that they are, in some sort, false dandies. They are also debauched Dadaists. After pedantically holding forth upon the maxim "And without bloodshed, there is no forgiveness" (which they falsely attribute to Baudelaire), they end up exclaiming: "It's Dada-esque!" A would-be dandyism, mixed with scorn.

Through these four characters, Pasolini offers a caustic critique of petit-bourgeois, falsely intellectual Fascism. Their desires are as hollow as their speeches. They are incapable of taking pleasure from anything except power for the sake of power, order for the sake of order, and so they feel nothing. By their attitude, they seem to confirm Foucault's intuition that Nazism was invented by "the most sinister, boring

and disgusting petit-bourgeois imaginable. [...] Eros is absent"(*Cinématographe*, December 1975). A disconcerting realization: "Libertinism," as Octavio Paz wrote, "is not a school of extreme sensations and passions, but rather the search for a state beyond sensations. Sade proposes a logical impossibility or a mystical paradox: to enjoy insensibility." Even a libertine's crimes leave him cold. That is why no one—neither the victims nor the viewers—can understand what the four dignitaries in *Salò* really want. Their apathy makes Pasolini's last film a totally a-psychological film, without plot development, its progression seemingly dictated only by a principle of gradually increasing horror. Aesthetically, this translates into the dull color-range of the images. "I shot *Salò* practically in black-and-white," Pasolini said. Everything contributes to the ennui, with no plot twists to distract the viewer from the horror of the spectacle.

Sade's most radical book

Hervé Joubert-Laurencin is right to emphasize "Sade's importance in getting artistic forms to overcome their own limits." In the case of *The 120 Days of Sodom*, this comes precisely through the work's impersonal quality, absolutely unprecedented in the eighteenth century, which makes it an anti-novel.

Unlike *Justine* or *Juliette*, the book contains no glimpse of interiority within its pages. The characters are opaque, without discernible psychology. From this point of view, Pasolini added nothing to Sade's text. Everything was already there. Chantal Thomas has aptly noted that the Sadean libertines "are the letter of their discourse." They do what they say and say what they do. And what they do is always evil. For Sade, there is "no innocent use of speech." This fact must have struck Pasolini, who was well placed to grasp its significance, having grown up under Fascism and participated, with Fabio Mauri, in the oratory contests during Hitler's visit to Florence in 1938. (This memory had been revived a few years earlier by his friend's performance *Che cosa è il fascismo*, which precisely sought to denounce Fascism's indoctrination by speeches). Granted, *Salò* is not entirely void of a tragic dimension, but it is not expressed on the level of the distinguished libertines. "Tragic people are torn people," as Frank Vande Veire put it. The four libertines are absolutely imperturbable in their cruelty.

This lack of interiority is what makes *The 120 Days* tend towards abstraction, and also what constitutes its undeniable modernity. The novel's abstractness certainly pushed Pasolini to choose this particular text of Sade's, as it echoes his own reflections as a novelist. In *Petrolio*, doesn't Pasolini insist upon his "distrust of all conventional psychology, all linear narrative and plot"(René de Ceccatty)? Further, by avoiding the particular, Sade's narrative directly attains a form of exemplary generality that Pasolini had been interested in since his earliest films. Here, the tragedy unfurls in the absence of drama itself. Here, evil is everywhere: it has become the impersonal structure of the world. More than any other work of Sade's, *The 120 Days of Sodom* was suited to becoming, "a medieval mystery play, a sacred, enigmatic performance," as Pasolini described his film in an interview on April 2, 1975.

And yet, despite its vaunted hermeticism, the general meaning of the film is fairly clear. As we have indicated, and as Pasolini himself said, the film's "explicit theme is ideology." Through this film, whose double nature, at once ceremonial and metaphorical, indeed recalls medieval mystery plays, Pasolini pursues a goal: to compose an indirect critique of the consumerist society of his time. This explains why the references to the Republic of Salò disappear almost completely after the first ten or so minutes of the film, leaving only a "fantasy." The context of 1945 has to fade quickly for the viewer to perceive beneath it, as if in transparency, the world of alienation and reification of 1975.

An indirect critique of consumerism

Sadean society is strictly hierarchical and typically aristocratic. More precisely, it reflects a "golden age" (or dream) of feudalism. Its implacable cruelty is paired with a doctrine of predestination. Since the beginning of time, Juliette has been saved and her sister Justine condemned to the worst misfortunes... Nazism makes a similar claim with its hierarchy of races, the only difference consisting in its scientific pretensions. The transposition of Sade's text to the Republic of Salò therefore presents no difficulty. Under a first interpretation, the setting allows Pasolini to denounce the radical modernity of horror. But one must go further. Beyond Fascism, Pasolini has another target indirectly in his sights: capitalism.

This should come as no surprise, given Pasolini's Marxism. It only takes a slight shift to pass from the master/slave dialectic of the French Ancien Régime to the class struggle that dominated the late-nineteenth century and the entirety of the twentieth. For Sade, this divide is radically expressed: on one side, the indifferent masters; on the other, the herd of the condemned. For Pasolini, the egotism of the masters ("We laugh at the torments of others") reflects the violence that capitalists exert over the proletariat. An extended parallel therefore arises from Sade's text, with the master/Nazi/capitalist on one side, and the victim/subhuman/proletariat, on the other. René Schérer summarizes this: "The complexity, the grandeur, of *Salò*, comes from the interference between different fields: that of Sade's text; that of the anecdotal Republic of Salò, the ephemeral refuge of collapsed Mussolinian Fascism; and that of consumer society, intensely though only allusively present, with its sexuality on display, but controlled and normative, transformed into a technical operation to be performed upon the body."

For Pasolini, the capitalism of his era leads to alienation. His analyses of consumerism link up with those of Adorno (*Minima Moralia*, 1951), Barthes (*Mythologies*, 1957), Marcuse (*One-Dimensional Man*, 1964), and Baudrillard (*The Consumer Society*, 1970). Pasolini, however, goes further in his conclusions. For him, modern capitalism leads to a veritable "anthropological revolution" that he sees as a "genocide"—his word—situated in the logical extension of the Nazi enterprise. Consumer society, that "catastrophe of catastrophes"(*Lutheran Letters*), is even "crueler, more distorting, more culpable than the historical Fascism of Mussolini, since it presupposes a more unconditional adherence to its structures from the people"(Éric Marty). In the *Corsair Writings*, Pasolini pronounces a broader judgment: "The hedonist ideology of the new power is the worst kind of repression in human history." As the four libertine villains murder their innocent victims, so the neo-capitalist order annihilates the singularity of the proletariat. Generalized hedonism, an inauthentic universal, dissolves all particularisms. The petit-bourgeois, animated by "miserly consumerism"(*Corsair Writings*)—which Pasolini opposes to "the peasant world and its tremendous purity"(*Petrolio*)—is a new race degraded by the order to seek pleasure. Logically, this new man—the "mass man"(*Corsair Writings*)—goes about his business in a new landscape. Pasolini accordingly describes, in *Petrolio*, "the new era that

is about to disfigure for eternity the old cities and the old countryside." This era will leave in its wake the new industrial landscape that Antonioni had already portrayed in 1964 in *Red Desert*, a scenery made of social housing that Pasolini filmed in *Accattone* and *Mamma Roma*.

One finds this idea of an alienating, false permissiveness—"modern tolerance of the American type"(*Corsair Writings*)—in Jean Eustache's short, fascinating film *A Dirty Story* (1977), when the main character, played successively by Jean-Noël Picq and Michael Lonsdale, voices his complaint about modern times. "Especially now, in our era," he says, "when you can't get to know a girl for more than two minutes before she tells you all her kinks, what turns her on the most, and everything... you wonder what you can do... you have to remind them, now, that it's a sin to be able to enjoy it a little, otherwise they do it like it's hygiene." When one of the women he is speaking to (or speaking *at*, since this is very nearly a monologue) calls him disillusioned, he replies, "No, I'm not disillusioned, it's a disillusioned era, of unprecedented sexual repression... I miss the Victorian era." Needless to say, the sexual repression here consists in being ordered to seek pleasure. This is a paradoxical, and typically Pasolinian, idea. As Pasolini writes:

> First: the progressive struggle for democratization of expression and for sexual liberation has been brutally superseded and canceled out by the decision of consumerist power to grant a tolerance as vast as it is false.
> Second: even the "reality" of innocent bodies has itself been violated, manipulated, enslaved by consumerist power—indeed such violence to human bodies has become the typical feature of our time.
> Third: private sexual lives (like my own) have suffered the trauma both of false tolerance and of physical degradation, and what in sexual fantasies was pain and joy has become suicidal disappointment, shapeless torpor. (*Lutheran Letters*)

This levelling, which strikes individuals at their core ("their lack of vitality is a real physical fact," Pasolini writes elsewhere in the *Lutheran Letters*) is all the more dangerous in that it leads to the obliteration of the political conscience. Without a critical approach to existence, without asking oneself what a just and happy life is, and what things are superfluous or necessary, no rebellion is possible. And no freedom is possible. Yet, these questions that humanist culture inherited from classical philosophy are becoming more and more distant as capitalism propagates its alienating "mass culture."

Consumerism creates individuals who are "anxious for normalcy" and whose allegiance to the "horde" is "total and unreserved." According to Alberto Brodesco, Pasolini sees Sadean sexuality as "a metaphor for the ways in which power takes possession of human bodies. Crushed by mechanisms of commodification, sex loses the liberating function it once held in punitive communities. [...] In a falsely tolerant society, the new alleged sexual freedom accorded by upper-class society coerces lower-class society to adapt to this type of freedom, and this type only."

Pasolini gave a clear statement of his intentions for *Salò* at least twice. First, in an article published on March 25, 1975, in the *Corriere della Sera*: "Aside from the metaphor of the (obligatory and ugly) sexual relationships that the tolerance of consumerist power imposes on us nowadays, all the sex in *Salò* is also a metaphor for the relationship between power and those who are subjected to it. In other words, it is the (perhaps oneiric) representation of what Marx calls the commodification of man, a reduction of the body (through exploitation) to a thing. Therefore, sex is still called upon to play a horrible metaphorical role."

Then, during a lecture Pasolini delivered at a *liceo* in Lecce in October of the same year: "I have made a film called *Salò*, drawn from Sade, in which one sees terrible things, which in reality, taken one at a time, would be pornography, taken out of context; but in context I believe that they are not, because the context is that of the commodification which power has made of bodies, that is the reduction of bodies to things, and so all of these sexual relationships are a metaphor of this commodification." *Salò* is an allegory: innocent bodies subjected to consumerist power.

In sum, the film does not aim to present Sade's hell as the truth of Fascism, but rather to reveal the Fascist nature of post-WWII consumer society. For Pasolini, consumerism, in the name of freedom and emancipation, has achieved what even Fascism could not, by stripping the masses of their vitality and bringing about "an inexpressive world, without particularities and diversities of culture, perfectly homogenized and acculturated"(*Corsair Writings*). The false permissiveness imposed by consumer society is in fact the mask of a power that exerts as violent a control over the life of individuals as historical Fascism did. Under this reading, the order staged in *Salò* is this neofascism's hidden truth.

A godless world

For Pasolini, the triumph of consumerism had a further consequence: the dechristianization of Italian society. This is a theme he often returned to in articles written for the press, starting in the early 1970s. It is not surprising, therefore, to find echoes of it in *Salò*.

Like *Mamma Roma*, *Salò* has a wedding scene. But in the latter case, it is a parody of marriage, held between two of the victims at the behest of the four distinguished villains. Pasolini nevertheless calls upon classical painting and the lessons of Roberto Longhi here. In the scene, the young girls accompanying the bride hold white lilies in their hands. These evoke the Annunciation, as it has been commonly represented by artists since the fourteenth century. In their paintings, the lily branch carried by the archangel Gabriel as he comes to announce to Mary that she will be the mother of God has a twofold function: it symbolizes Mary's purity and virginity, and it indicates that the scene takes place in spring, or nine months before Christmas.

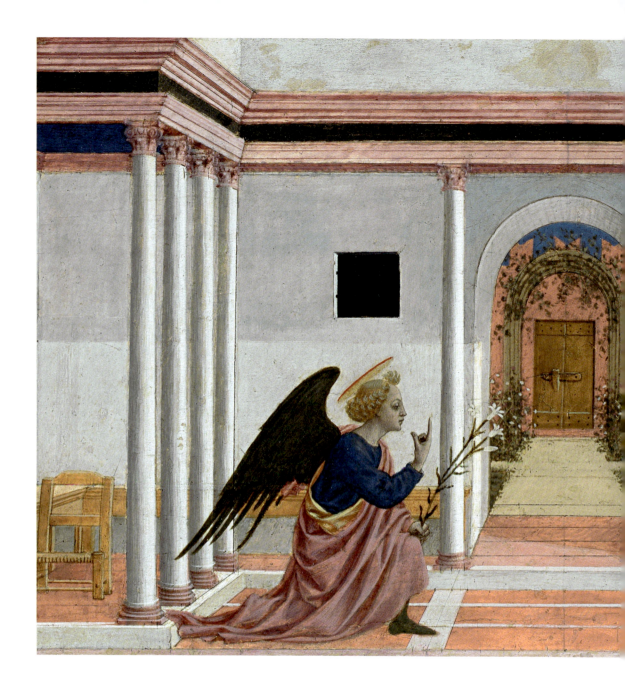

Fig. 94　Domenico Veneziano, *Annunciation*, c. 1440–1450, tempera on wood panel, 11 × 21½ in. (27.3 × 54 cm), Fitzwilliam Museum, Cambridge

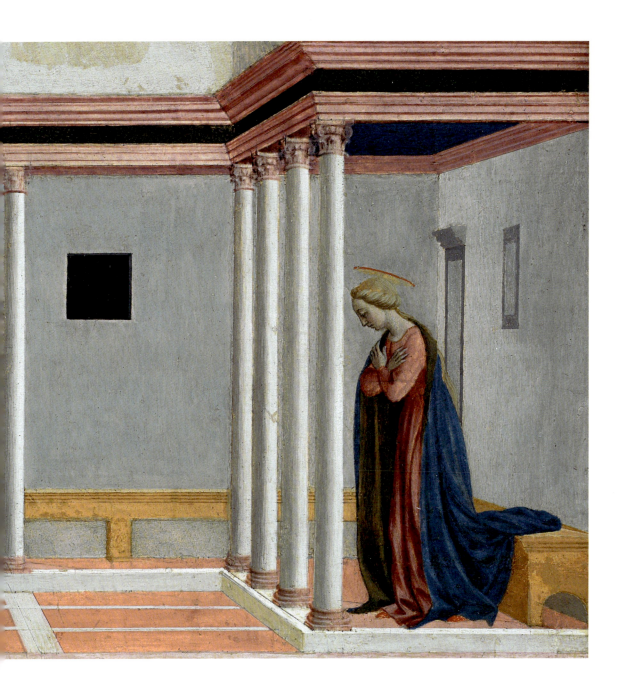

Pasolini at the Château de Silling

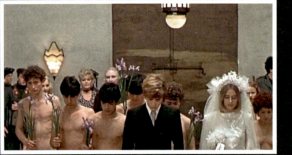

Fig. 95

Fig. 95 *Salò, or the 120 Days of Sodom*, 1975 (detail)
Fig. 96 Anonymous, *Annunciation*, 17th century, oil on copper, 6½ × 9 in. (17 × 23 cm), Nouveau Musée National de Monaco
Fig. 97 Lodovico Cardi, *Annunciation*, n.d., oil on canvas, 34½ × 28 in. (88.2 × 70.5 cm), FABA—Fundación Almine y Bernard Ruiz

Fig. 96

Fig. 97

In the context of the film, this Christian symbol is, of course, blasphemous. The ceremony orchestrated by the four libertines is only a masquerade meant to ridicule the sacrament of marriage. In *Salò*, God is absent. Pasolini shows himself faithful to Sade's text and to Sade himself, who preached radical atheism. It is true that *Salò* contains many Christian references or allusions (we see, for instance, a boy sitting on the ground trace the word "*Dio*" in the dirt, or another boy, naked, his body pierced with bullets, recreate in death the languidly masochistic pose of Baroque Saint Sebastien paintings), but these references are evoked only to be finally denied. This is clearly shown by one of the victims who, plunged naked with others into a vat of shit (a Sadean punishment inspired by Canto 28 of Dante's *Inferno*), speaks the words of Jesus himself, "My God, My God, why have you forsaken me?"

The obliteration of Christianity, however, does not hold the same meaning for Sade as for Pasolini. Sade wishes for it when it hasn't happened yet; Pasolini regrets it when it has. The general meaning of *Salò*, which is a critique of consumerism, sheds light on one of the most perplexing aspects of Pasolini, for his admirers as well as his despisers: his simultaneous adherence to Marxism and to Christianity. In Pasolini's eyes, modern capitalism caustically attacks both alike, as they are two faces of the same humanist culture. Modern capitalism leads to a standardization of the individual, who, having become a materialistic petit-bourgeois, no longer has access to such forms of transcendence as utopia and religion. From then on, he lives without an ideal, under an empty sky. This collapse is the postmodern crisis.

When Pasolini took his stand as a defender of tradition—or even, provocatively, as a reactionary—he did so in opposition to the destructive transformations that come with neoliberalism. His perspective was almost solely cultural. What he wanted to preserve were the culture and the languages of the peasant world, the underclasses, the margins. On a deeper level, it was an even more ancient past, an immemorial archaism, that he wanted to keep from oblivion. As René Schérer well saw, "for Pasolini myth is reality and reality is mythical." This is fairly clearly demonstrated by *Petrolio*, a key work in the confusion between myth and reality, and also by such a film as *Theorem*.

Is it not precisely this irruption of myth into reality, whether explicit or implicit, that gives Pasolini's images their uncanny force? As René Schérer writes, "There is no comparing this to a purely aesthetic use of mythology, like that of Cocteau, for example, whose creations, in spite of their undeniable poetic value, remain confined to artificiality. On the contrary, for Pasolini the treatment of myth opens directly onto reality itself; it is an escape toward an unexpected, extraordinary reality, like unsealing our eyes."

The loss of the mythical dimension of existence might allow the advent of modern liberty, but it also opens the way to the evil inherent in that liberty. With the modern, we pass from the age of tragedy to the age of evil. This the evil that culminates in Nazism. And the evil that Pasolini denounces in *Salò*.

Postmodern Tragedy

In the ancient tragedies, notably those Pasolini adapted to film, the inhumanity of History is interiorized as destiny. If Oedipus, no matter what he does to avoid it, is doomed to kill his father and marry his mother, it is because he has been cursed since before his birth. We have seen how this idea underlies Sade's vision of a society divided into master-torturers and servant-victims. Nevertheless, from Sade's aristocratic perspective, the separation between the two groups is comprehensible because it is largely determined by ancestry. *Salò*'s profound modernity consists in acknowledging that the twentieth century has rendered all explanations absurd. Evil does not have a reason. Carried to its logical conclusion, Sade's world, with nearly no possibility of escape, allows Pasolini to reactivate Greek tragedy. Contrary to what we see in *Theorem*, no final conversion is possible in *Salò*: what is acted out here is tragically unredeemable.

While the archaic and the postmodern worlds are opposed to each other in their fundamental meaning, they merge with each other in their results. Both of them, emptied of all properties, are "rendered unto the original chaos of destinies, a world of pure conflict from which the only possible escape is death"(Éric Marty).

Fig. 98 Anonymous (School of Caravaggio), *Saint Sebastian Pierced by Arrows,* c. 1620–1630, oil on canvas, Museo Civico P.A. Garda / Guelpa Croff Collection, Ivrea
Fig. 99 *Salò, or the 120 Days of Sodom,* 1975

Fig. 98

Fig. 99

Pasolini at the Château de Silling

One might find confirmation of this interpretation in the film's final image: two young militiamen cheerfully dancing a foxtrot to the same melody we heard during the opening credits. By framing the horror, don't these two brackets of cheerfulness relativize it as well? Horror becomes merely one of many manifestations of *fatum* (fate). Postmodernity coincides with Antiquity in its tragic dimension, its inexorability—A tragedy turning mediocre, without a measure of greatness..

A possible redemption?

But let us watch a little longer these two young militiamen dancing in the sitting room of the villa. The scene takes place right after the last victims have been tortured to death by the four libertines. Let us watch and, above all, listen: "What's your girlfriend's name?" one of them asks. "Marguerite," the other replies. These are the last words spoken in *Salò*. The film closes on a girl's first name, one of the most famous first names in European literature, since it was the one that Goethe gave to Faust's mistress. There is nothing random about this choice, but its interpretation remains open.

In Part One of Goethe's *Faust* (1808), Marguerite is a woman seduced by an alchemist who has made a pact with the devil. Pregnant and abandoned, she has to drown her child and ends up in prison. She appears to be the victim of a cruel, "sadistic" game, as Hervé Joubert-Laurencin has noted. Here is one more victim, we might be tempted to say, of men's egotism and cruelty... From this perspective, the evocation of Marguerite at the end of *Salò* simply acts as a confirmation. One might nevertheless have a doubt that Pasolini found it necessary to drive home the point, since the entire film has just been a demonstration of the darkness of humanity. For that reason, another interpretation, proposed by Giovanni Buttafava, seems more plausible to me: "In a film that is a pitiless x-ray of the demonic corruption of culture [...], the name [of Marguerite] is a clear sign of an ultimate, desperate faith in the possible salvation of that same culture, and of the world." Indeed, in the second part of *Faust* (1832), Marguerite is the one who saves her alchemist lover with her prayers. Though corrupted by culture, Faust is redeemed, *in extremis*, by a pure, selfless love. This interpretation of *Salò*'s last scene appears to be supported by the choice of the room in which the two militiamen are dancing: the villa sitting room

decorated with modern paintings. Doesn't this sitting room symbolize an authentic form of art, in contrast to the falsely refined, nihilistic culture of the four distinguished Fascists? The name of Marguerite resonates all the more strongly here. It indicates a last resort: "a multiple, magmatic, religious, and rational view of life," nourished by "humanist values"(*Corsair Writings*). *Salò*'s final scene opens toward a possible redemption.

Descendants

Dino Pedriali, *Pasolini*, 1975, silver gelatin print, 12½ × 15½ in. (30 × 40 cm), private collection

By his controversial work and the violent death that seems to crown it, Pasolini has come to symbolize a time when the artist's and thinker's role was principally defined as a resistance against order and the powers that be. His contemporaries sometimes deemed his stances polemical and his warnings against consumerism exaggerated. Only Pasolini's radicalism can explain how such a faithful friend as Alberto Moravia could define his thought as a "paradoxical, aggressive sociology [...], with its mixture of Marxist didacticism, existential anguish, pessimistic historicism, and nostalgia for Enlightenment philosophy."

But where do things stand today? Decades later, Pasolini's body of work appears in all its breadth and diversity. His work was made out of step with its time, or even against its time, to open the way for future thought. It is now brilliantly contemporary. Was Pasolini an artist-intellectual? There can be no doubt he was, if to think actively means "acting counter to our time and therefore on our time, and, let us hope, for the benefit of a time to come," as Nietzsche wrote in his *Untimely Meditations*. The "time to come" that Pasolini foretold has arrived: it is our own, a time of the fetishization of merchandise and of violent normalization, particularly visible in the arts.

It is precisely because the idea of the artist as a figure of dissent has begun to fade that a return to Pasolini has seemed necessary to me. Too often today, art claims to express the good: our art is green, inclusive, instructive, etc. It is a visual manifestation of the dominant political discourse. One might describe it with same adjectives Malaparte chose when he spoke of modern death. It is "disinfected, polished, nickel-plated." Unfortunately, by refusing to acknowledge its share of anathema, art becomes commonplace and tends towards the condition of mere merchandise. Let us hold Pasolini up as an example, then, so that art stays art, and Pasolini remains our contemporary.

Homage to the departed

"A society that kills its poets is a sick society," Alberto Moravia declared on November 6, 1975, the day of Pasolini's funeral. Four days earlier, the body of the famous Italian artist had been found next to the beach in Ostia, near Rome. This murder committed on the night of November 1, 1975, provoked heavy emotion throughout Italy and among a great many artists, continuing to this day. They have paid homage to him by evoking either his death or his work. This was demonstrated in the beautiful exhibition *Pier Paolo Pasolini. Tutto è santo. Il corpo politco* (MAXXI, November 16, 2022–March 12, 2023) through an eclectic selection of works. In order to respect the general theme of this essay, I have mostly chosen drawings and paintings that are in keeping with the Mannerist and Baroque traditions dear to Pasolini, as well as works (mostly videos and installations) that refer directly to his films.

Right after the tragedy, Giovanni Fontana (b. 1946) made a collage out of two copies of the Italian communist newspaper *Paese Sera* (now defunct), with the banner headline "*Pasolini assassinato.*" Fontana cut out the letters of Pasolini's name and reordered them to spell "*Io piansi.*" The collage thus forms the sentence, "*Pasolini assassinato, lo piansi,*" or "Pasolini murdered, I mourned him." The extraordinary thing is that *Io Piansi* is an anagram of Pasolini—as if it were the sign of a destiny. Was Pasolini, like Oedipus, whose tragic tale he adapted to film, doomed even before he was born?

Several other artists have made works about Pasolini's death, undoubtedly stirred by its savagery (he was punched, kicked, and bludgeoned to death with sticks before being run over with his own car, an Alfa Romeo GT) and by its unclear motives, which are still the subject of debate today.

Fig. 100

In 1980 Ernest Pignon-Ernest (b. 1942) hung four hundred serigraphs on the walls of Certaldo, Bocaccio's native city; several of them depicted a naked Pasolini, crucified upside-down. In a monograph published in 1990, Pignon-Ernest later wrote of this work, "One can understand why the image of a public crucifixion, an "inverted" crucifixion, felt inevitable." Pasolini, crucified in public? The image is powerful, but not imprecise. Pasolini was repeatedly attacked for his homosexuality not only throughout his life, but even after his death during the trial of his murderer, Pino Pelosi, whose lawyer, given a broad platform by the press, did not hesitate to portray Pasolini as a corrupter of youth, responsible for his own death.

Thirty-five years later, Ernest Pignon-Ernest came back to Pasolini's death. He offered a new interpretation of it, perhaps more accomplished, playing on the idea of the double (an idea that subtly recurs throughout Pasolini's work and is key to *Petrolio*). In this new series of serigraphs, titled *Si je reviens* [If I return] and posted on the margins of the beach in Ostia, Pignon-Ernest imagines Pasolini carrying his own corpse in his arms, dressed in the same clothes as in the police photographs taken after his murder. The Christian reference is evident, as it is in the first series of serigraphs from 1980. In the catalogue to his 2022 exhibition at the Fonds Hélène & Édouard Leclerc pour la culture, Pigon-Ernest wrote, "My drawing can be seen as a *Pietà*, Pasolini carrying and presenting his own corpse: an accusation? a statement of fact? a warning? a question? 'What have you done with my death?" By citing Michelangelo's *Pietà* in *Si je reviens*, Pignon-Ernest mirrors Pasolini's own film citations of Pontormo or Caravaggio. In doing so, he shows his intimate knowledge of Pasolini's work, an homage within an homage.

Fig. 100 Giovanni Fontana, *Anagramma,* 2002 / 2022, digital print on cotton paper, 28½ × 20½ in. (72.6 × 52 cm), artist's collection

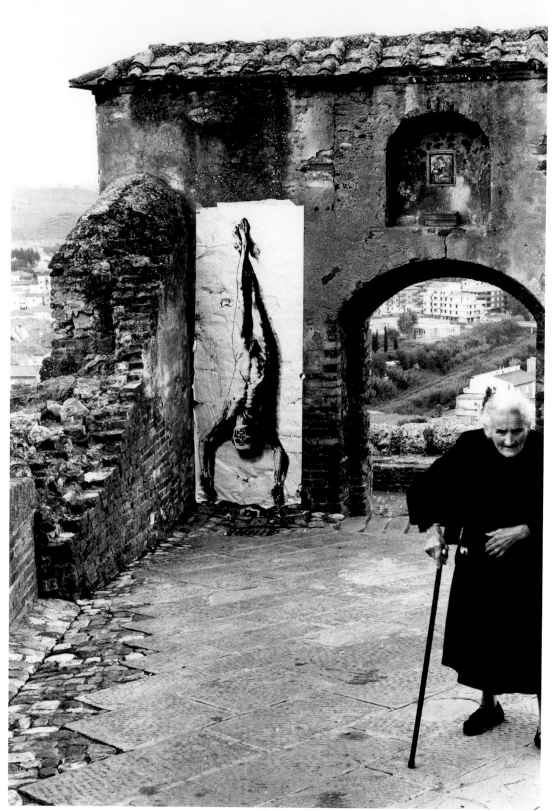

Fig. 101

Fig. 101 Ernest Pignon-Ernest, *Pasolini*, 1980, silver photography, 30½ × 20½ in. (78 × 52 cm), courtesy of the artist and Lelong & Co., Paris
Fig. 102 Ernest Pignon-Ernest, *Portrait Pasolini*, 2000, black chalk and ink on paper, 8½ × 8½ in. (21.5 × 21.5 cm), courtesy of the artist and Lelong & Co., Paris

Fig. 102

Fig. 103 Ernest Pignon-Ernest, *Pasolini Assassiné—Si Je Reviens. Ostia 1* (Pasolini Murdered—If I Come Back. Ostia 1), 2015, digital print mounted on Dibond, 26 × 39½ in. (66 × 100 cm), courtesy of the artist and Lelong & Co., Paris

Fig. 103

The beach of Ostia is also where Cerith Wyn Evans (b. 1958) chose to shoot his 16mm film in homage to Pasolini. Evans, an erudite artist, admirer of Kenneth Anger and Guy Debord, had the idea for this work when, in the restaurant Il Pomodoro, he happened upon the framed, uncashed check from Pasolini's last dinner before the murder. This short film (15 min) shows a group of men installing, on plain wooden posts, a phrase from the script of *Oedipus Rex* that fireworks soon set aflame in the night: "On the banks of the Livenza, silver willows are growing in wild profusion / their boughs dipping into the drifting waters." What better word than the beautiful *drifting*, with its layered meanings, to sum up the life and death of Pasolini, and seal an ephemeral epitaph traced in the night?

The American conceptual artist Jenny Holzer (b. 1950), whose work principally consists of presenting brief texts in the public space, took inspiration from a Pasolini poem to make a marble bench, on the seat of which can be read in capital letters, "*Passivo come un uccello che vede / tutto, volando, e si porta in cuore / nel volo in cielo la cosciencza / che non perdona*" (Passive as a bird who sees all, in his flight, and keeps in his heart, while he flies through the sky, the consciousness that does not forgive.) These four lines, taken from the collection *Poem in the Shape of a Rose* (1964), seem to appeal to a typically undeceived Pasolinian consciousness. They can accordingly be seen as a maxim bequeathed by Pasolini to future generations.

Fig. 104 Cerith Wyn Evans, *Pasolini Ostia Remix* (detail), 1998–2003, super 16mm film, color, soundless, 15' on loop, Centre Pompidou—Musée national d'art moderne / Centre de création industrielle, Paris
Fig. 105 Jenny Holzer, *La Coscienza*, 2019, curved bench in Versilys marble and gold, 17 × 41½ × 18 in. (43.2 × 106 × 45.7 cm), courtesy of the artist and Hauser & Wirth

161

Fig. 104

Fig. 105

Descendants

The photographs of Pasolini's corpse published in the press would later serve as a model for several artists. The South African artist William Kentridge (b. 1955) reworked the most famous one in *Triumphs and Laments* (2016), an immense ephemeral mural in Rome along the banks of the Tiber. The mural, over 1800 feet (550 m) long, was created with stencils (Kentridge made the figures appear by power-washing the walls around his drawings for them to take form in the darker, uncleaned deposits), and it evokes the history, or rather mythology, of Rome through eighty figures, from antiquity to today. Pasolini's death thus finds itself placed on the same level as Romulus and Remus's founding of Rome. Kentridge also renders a version of Pasolini's face in the form of what he calls a "sculpture." This is a reworking of his drawing, this time cut out of cardboard, and affixed at a slight distance from the wall.

Fig. 107 William Kentridge, *Death of Pasolini*, 2015, preparatory drawing for *Triumphs and Laments*

Fig. 106 Pier Paolo Pasolini's remains, 1975. With the kind permission of Simona Zecchi

Fig. 106

Fig. 107

Fig. 108 William Kentridge, *Triumphs and Laments* (detail), 2016, over 1800-foot-long (550-m) frieze along the banks of the Tiber (Rome)

Descendants

The painter Bruno Perramant (b. 1962) has also made a painting based on the police photographs of Pasolini's corpse. But by choosing an image in which Pasolini appears disfigured, truly pitiful, the work does not avoid the easiness of shock images.

Martial (b. 1968) shows greater finesse in his approach. The box he created is a kind of *memento mori*. We see Pasolini walking on a beach. He has the chiseled body of an athletic thirty-nine-year-old, a "glorious body," to use a term from Catholic theology. A pair of large black butterfly wings, spotted with green, emphasizes the fleetingness of this glory, while thunderclouds in the distance weigh ominously upon the scene. The nameless beach where Pasolini calmly walks inevitably recalls the beach of Ostia and the tragedy to come. The lines of Pasolini's poetry handwritten on the white wings of a second figure (Martial himself) confirm this reading: "The world has no regrets: every creature flies and falls."

Fig. 109 Martial, *Toute Créature Vole et Sombre* [Every Creature Flies and Falls], 2023, mixed technique, 15½ × 20 × 2 in. (39 × 26 × 5 cm), artist's collection

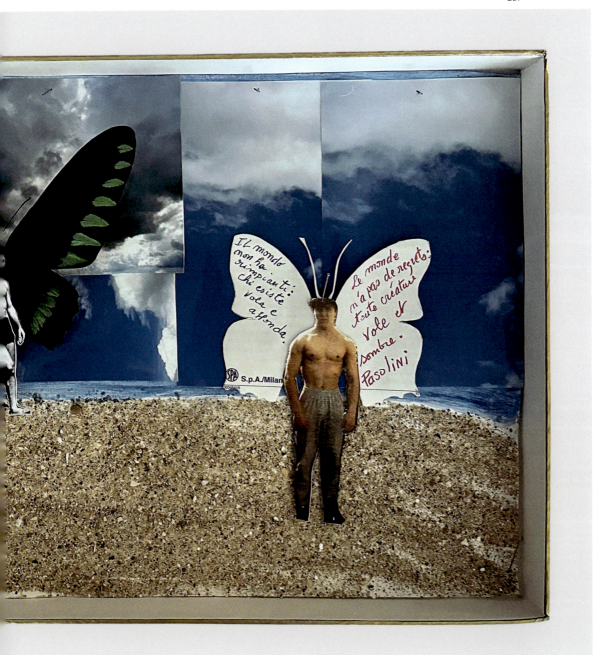

Fig. 109

Descendants

Fig. 110 Giulia Andreani, *Balilla*, 2018, acrylic on canvas, 14½ × 10½ in. (35 × 27 cm), Daniel Durrieu Collection

Fig. 110

A number of artists have chosen to pay homage to Pasolini in the most classical, most moving, way of all, by painting his portrait. Among them, one might cite Giulia Andreani (b. 1985), who in *Balilla* paints him as a young child when he was enrolled in a Fascist youth group; Stéphane Mandelbaum (1961–1986); Giuseppe Stampone (b. 1974); Marlene Dumas (b. 1953); and Adel Abdessemed (b. 1971). The last two, Dumas and Abdessemed, included Pasolini in larger portrait series with other admired artists.

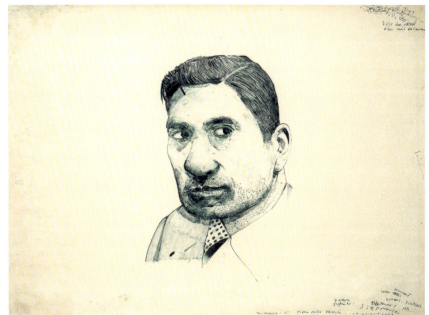

Fig. 111

Fig. 111 Stéphane Mandelbaum, *Ritratto di Pier Paolo Pasolini*, 1980, ball-point pen on paper, 20 × 27½ in. (50.4 × 69.6 cm), private collection

Dumas' work, accordingly, is part of her sixteen-piece *Great Men* series (2014), portraits of men persecuted for their homosexuality. Two years earlier, proof of the importance she accords to him, Dumas had already made two identical-format oil paintings of Pasolini and his mother. Abdessemed's series *Charbon*, for its part, is composed of forty-four black-chalk drawings that form a portrait gallery of friends and admired artists. It should come as no surprise (if one believes in Henri Focillon's idea of "spiritual families") that at least two of the figures depicted by Abdessemed were also dear to Pasolini, namely Caravaggio and Orson Welles.

Francesco Vezzoli (b. 1971) may be the one who found the simplest, most compelling form to evoke the death of Pasolini, by overlaying a black-and-white portrait of him with the word *fine* ("the end"). The nod to cinema is all the more evident in that the image is placed between two horizontal black bands, like films shot in 16:9 when they are projected onto 4:3 screens or broadcast on television.

Fig. 112

Fig. 113

Fig. 112 Marlene Dumas, *Pasolini*, 2014, oil on canvas, 15½ × 12 in. (40 × 30 cm), artist's collection
Fig. 113 Marlene Dumas, *Mère de Pasolini* [Pasolini's Mother], 2014, oil on canvas, 15½ × 12 in. (40 × 30 cm), artist's collection

Fig. 114 Adel Abdessemed, *Pier Paolo Pasolini*, 2016, charcoal on paper, 23½ × 15½ in. (60 × 40 cm), Jacques Grange Collection
Fig. 115 Francesco Vezzoli, *Fine*, 2004–2013, lazer print on canvas with metal embroidery, 14 × 17 in. (35 × 43 cm), MAXXI—Museo nazionale delle arti del XXI secolo, Rome

Fig. 114

Fig. 115

Descendants

The force of images

As one might expect, it is Pasolini's films, rather than his poems or novels, that have inspired artists the most, whether they are painters, photographers, or video artists. Given that Pasolini's films were themselves strongly influenced by painting, it is fitting for them to have in turn inspired painters and printmakers. The films' most striking shots, already composed like paintings, have sometimes been used almost exactly in their original form. That is the case, for instance, with the twelve watercolors made by the Albanian artist Adrian Paci (b. 1969) in 2019, based on *Medea*. The series is emblematic of Paci's work, which is entirely constructed in relation to moving images, whether amateur videos, YouTube extracts, or classic films like those of Parajanov and Pasolini. In the case of classic films, Paci's approach consists in depriving images of their context so that viewers inhabit them in new ways. In a brief interview with Bartolomeo Pietromarchi, he spoke of applying this method to Pasolini: "By subjecting the frames of his films to the language of my painting, I construct pictorial narratives by following a path backwards that, according to Pasolini, started from painting itself. Pasolini's work is made up of the iconographic memory of his passionate gaze. Focusing on this memory through my painting was one of the reasons that pushed me to reflect on starting this dialogue."

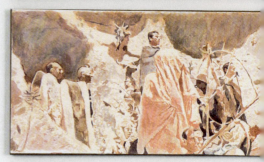

Fig. 116 Adrian Paci, *Medea*, 2017–2019, watercolors on paper mounted on canvas, twelve parts, overall dimensions: 65½ × 86½ × 1 in. (167 × 220 × 2 cm), each watercolor: 15 × 27½ × 1 in. (38 × 70 × 2 cm)

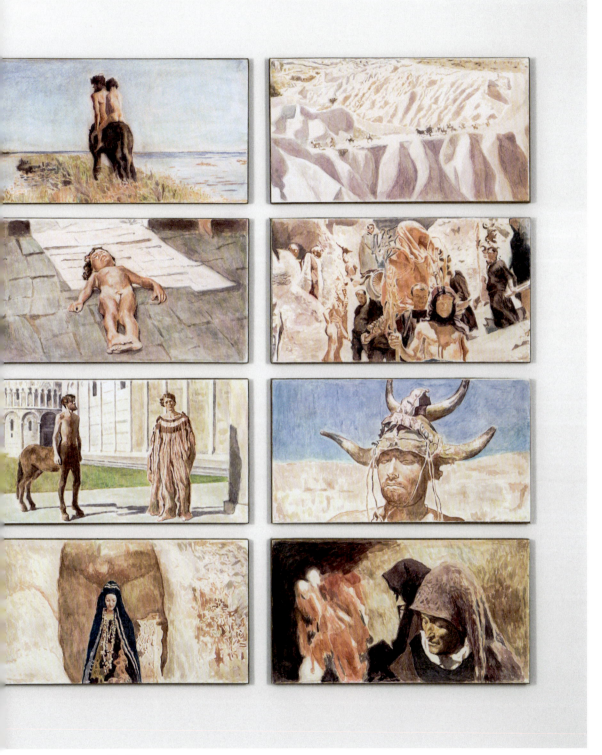

Fig. 116

Descendants

Figs. 117, 118, 119 Giuseppe Stampone, *P.P.P. Made in Italy (Triptych)*, 2015, triptych, ball-point pen on paper, 19½ × 15½ in. (50 × 40 cm) (each), courtesy of the artist and of Prometeo Gallery Ida Pisani, Milan / Lucca

Figs. 117, 118

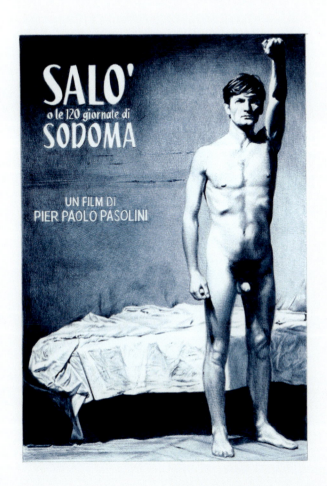

POLITICS

Fig. 119

Among the pictorial shots created by Pasolini, we might cite the moment in *Salò* when we see one of the young assistants stood naked, with raised fist, facing the four Fascist dignitaries about to shoot him. Giuseppe Stampone has meticulously reconstructed this frame in a drawing he accompanies with the caption "POLITICS," underscoring the scene's political dimension. Stampone had the following to say about this during a telephone conversation: "If I added that caption to my drawing, which could be described as "well made" or "pretty," it's because I wanted to affirm that ethics takes precedence over aesthetics. Art is a political matter."

Other artists have preferred to isolate a detail, like Marlene Dumas focusing this time on Anna Magnani's anguished cry when she learns of the death of her son in *Mamma Roma*, or Astrid Klein (b. 1951) choosing to depict Pasolini himself (but at a three-quarter view from the back) in his role as a disciple of Giotto in *The Decameron*. Klein even offers a twofold homage to Pasolini by printing a line from his poetry on the canvas, "*la passione non ottiene mai perdono*" ("passion can never be forgiven"), a quotation that opens a dialogue between the text and the image. Who is Klein referring to? Pasolini in particular? Artists in general? Herself?

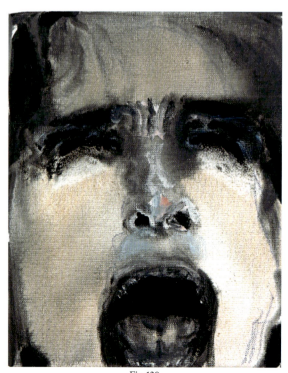

Fig. 120

Fig. 120 Marlene Dumas, *Mamma Roma*, 2012, oil on canvas, 12 × 9½ × 1 in. (30 × 24 × 2.5 cm), Pinault Collection, Paris
Fig. 121 Astrid Klein, *Untitled (Pasolini / Decameron)*, 1993, acrylic on canvas, 78½ × 73 in. (200 × 185 cm), courtesy of the artist and of Sprüth Magers, Berlin

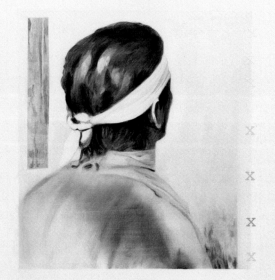

Fig. 121

Descendants

Fig. 122

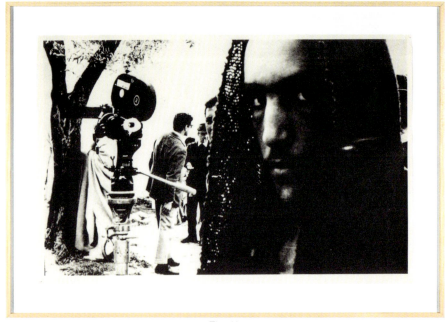

Fig. 123

Fig. 122 Walter Dahn, *First Impression*, 2012, acrylic and silk screen on paper, 15 × 24 in. (38.5 × 60.5 cm), courtesy of the artist and of Sprüth Magers, Berlin
Fig. 123 Walter Dahn, *Filmset (P.P.P. and E.I.)*, 2012, acrylic and silk screen on paper, 21 × 32½ in. (53 × 82 cm), courtesy of the artist and of Sprüth Magers, Berlin

For Walter Dahn (b. 1954) the film of reference is *The Gospel According to Matthew*, which he photographed to make new images from it. *First Impression* consists of the tightly-framed face of Enrique Irazoqui in the role of Jesus, accompanied by the phrase "A World That Might Have Been." According to Dahn's interpretation, Pasolini depicts Jesus as a social revolutionary. This is particularly evident during the Sermon on the Mount, the film's key scene where Jesus praises the poor, the meek, those who mourn, strive for justice, or work toward peace. Theirs is the "world that might have been."

In *Filmset (P.P.P. and E.I.)* we see a scene from the shooting of the film itself. In the foreground is the actor Enrique Irazoqui; in the background, Pasolini, seen from the back, behind a camera. The photograph establishes a dialogue between film images and their process of production. Dahn, who has often expressed admiration not only for Pasolini's films but also for his creative process (namely, how Pasolini drew inspiration from classical painting), finds a way here to evoke both aspects in a single image.

Richard Dumas, also struck by the *Gospel According to Matthew*, made a wonderful portrait, forty years after the film, of Enrique Irazoqui, the only plausible Jesus in the history of cinema, said Godard. Through his photograph, which draws its strength from the melancholy dignity of this aging "Jesus" seated at the edge of a bed, Dumas seems to want to remind us, like Martial, that all things pass. *Memento mori*...

Fig. 124

Fig. 124 Richard Dumas, *Portrait of Enrique Irazoqui*, 2003, inkjet print on Baryté paper, 14½ × 14½ in. (37 × 37 cm), courtesy of the artist and of Galerie S., Paris

Jean-Luc Verna (b. 1966) has created Perfecto jackets accompanied by drawings in homage to three great artists of his pantheon: Nico, Siouxsie Sioux, and Pasolini—a list that probably remains open. On the Perfecto devoted to Pasolini, each piece contains a more-or-less direct allusion to Pasolini's life and work: a Virgin Mary made-up like a *mignotta* (recalling at once *La Ricotta* and *The Gospel According to Matthew*), a young boy sitting astride a centaur (an allusion to *Medea*), a target (as he was, of so many unjust indictments), a reconstructed photograph of a Roman garden, a patch of the AS ROMA football club (Pasolini was a fan), and the lyrics to the song "*I ragazzi giù nel campo*," co-written by Pasolini and his friend Dacia Maraini for the Italian adaptation of *Sweet Movie* (1974), the burlesque-erotic bomb directed by Dušan Makavejev. (The jacket is thus "tattooed" all over its skin, like Jean-Luc Verna himself.) Alongside the jacket is a drawing of a beautiful angel–bad boy smoking a cigarette as he conspicuously lowers the thin veil draped around his waist... At the sight of him, how can we not think of Bernini's baroque statues on the Ponte Sant'Angelo in Rome, from which Accattone, in a memorable scene, dives into the Tiber?

Fig. 125

Figs. 125, 126 Jean-Luc Verna, *I ragazzi*, 2023, diptych, transfer of drawing on Bristol paper, enhanced with dry pastels, makeup, and Posca pens; transfer of six readymades on a black perfecto, reinterpreted and enhanced with colored pencils and Caparol, 38½ × 27 in. (98.2 × 69 cm), courtesy of the artist and of Espace à vendre, Nice and Ceysson & Bénétière, Paris

Fig. 126

Descendants

From filmmaker to filmmakers

Just as painters and printmakers have focused at times on Pasolini himself (by painting his portrait) and at other times on his films (by reappropriating certain shots), directors and videographers have portrayed either his life or his work.

Abel Ferrara, in his biopic *Pasolini* (2014), chose the first option. By filming the last day in the life of Pasolini, wonderfully played by Willem Dafoe, Ferrara wagers that a few hours can embody a life and catch its meaning. And so we see Pasolini, after a morning's work writing *Petrolio*, have lunch at home with his mother, his secretary, and two friends: the actress Laura Betti and the poet Nico Naldini. During the meal, his friends try in vain to convince him to stop writing incendiary articles against the powers that be. He then accords an interview to a journalist from *La Stampa* before having dinner with his ex-lover and driving off at the wheel of his Alfa Romeo GT, looking for action. In front of a bar, he has a young man get into his car. Together, they drive to the beach in Ostia where Pasolini is beaten to death. The spareness of the mise-en-scène, together with the beauty of the images, the biographical precision, and the attention to detail, makes *Pasolini* a true film—in every sense of the word.

John Waters took the opposite approach. Though a director himself, he chose to come to Pasolini as a visual artist, and not through the biography but rather through the works. In keeping with his transgressive humor, Waters made a collage from photographs of the pimples of Pasolini's actors. In an exchange of emails during preparations for *Pasolini in Chiaroscuro*, Waters summed up his project, "Pasolini lusted after actors with pimples. Here is his passion for acne isolated from his movies and spotlighted for the world to see." Do not let this provocative declaration deceive you, however. Waters's irreverent collage is still every bit an homage. This is apparent in his response to another email asking him what Pasolini films he used, and whether they were important to him: "Have no idea which movies but watched them all and chose men or young men who Pasolini seemed to be attracted to and many had pimples so I just zoomed WAY in and photographed the

Fig. 127 Abel Ferrara, *Pasolini*, 2014, film, 84'

pimples and then cut them out like a slow child in kindergarten and made the photo collage. I never met him but own a watercolor by him of a shepherd, all the books and do you know about my record called *Prayer to Pasolini* that came out last year on Sub Pop Records and easily can be found online? I recorded it at that great little park at the site where he was murdered. I also screened the documentary *Who Killed Pasolini?* [by Marco Tullio Giordana] on my short-lived TV show entitled *John Waters Presents Movies That Will Corrupt You*. My God yes his films were influential especially *Teorema*.
I presented *Salò* at Toronto Film Festival maybe 10 years ago. I pray to him every night."

Fig. 127

Fig. 128

Many video artists have created works based on Pasolini's films. In 1995, Pierre Huyghe made *Les Incivils*, a reconstruction of scenes from *Uccellacci e uccellini* (Birds, small and large). For the video, Huyghe returned to the film's original shooting locations with Pasolini's cherished actor Ninetto Davoli, and asked him to act out his part again thirty years later. Huyghe thus created a remake that interweaves the original version with the refilmed scenes, past and present.

Fig. 128　　John Waters, *21 Pasolini Pimples*, 2006, 21 uniquely cut C-prints, edition 4/5 + 1 AP, 35½ × 35½ in. (90.2 × 90.2 cm) (framed), courtesy of the artist, of Sprüth Magers, London and of Marianne Boesky Gallery, New York
Fig. 129　　Alain Fleischer, shooting still of *Anna Magnani, la Mère Fantôme* [Anna Magnani, the Ghost Mother], 2024, screening, soundless video, 9', coproduction Nouveau Musée National de Monaco / Le Fresnoy—Studio national des arts contemporains

The superposition of different time-frames is also at play in the work of Alain Fleischer. In his video *Anna Magnani, la Mère Fantôme* [Anna Magnani, the Ghost Mother] (2024), he projects onto the shooting locations of *Mamma Roma* the portrait of Anna Magnani, sixty years after her unforgettable turn in the film's leading role. He then films this devastating, ghostly portrait in long-tracking shots through the neighborhoods of Palazzo dei Ferrovieri, via Treviri, San Giovanni Bosco, and Trastevere. While certain sites have hardly changed since the 1960s, others are almost unrecognizable. Through this distance between past and present, Alain Fleischer shows how the passage of time changes all things, even Rome, the eternal city. He seems to ask this burning question: What remains of Pasolini's Rome? What remains of Anna Magnani? What remains, after all, except the images fixed in art?

Fig. 129

Such images are what Laurent Fiévet (b. 1969) superposes in his 2019 video *L'Annonce faite à Lucia* [The Annunciation of Lucia]. Over a brief excerpt from *Theorem* showing the mysterious visitor and the lady of the house sitting face-to-face in the villa garden—a scene that Fiévet nearly freezes in place for twenty minutes—he superimposes a series of annunciations.

Fig. 130 Laurent Fiévet, *L'Annonce faite à Lucia* [The Annunciation of Lucia], 2019, *Teorema* series (2019–2021), video, 20'34", artist's collection

In doing so, he offers a twofold commentary: on Pasolini's films in general (by emphasizing the fundamental role of classical painting in them) and on this film in particular (by making us see the visitor's angelic nature and the erotic nature of his relation with his hosts).

Descendants

Fig. 131 Charles de Meaux, *Two Voices in the Murky Light*, 2024, video installation, production Nouveau Musée National de Monaco

Charles de Meaux (b. 1967), in his video *Two Voices in the Murky Light*, also delves into Pasolini's relationship to painting, but he accompanies this with a reflection on the links between literature and cinema. His film opens with the image of a man wandering, book in hand, through the streets of Rome. The book he reads as he walks is by Pasolini. One cannot identify it, however. It is an "imaginary book," formed of fragments from various other (real) books. All these fragments are about the sociological dimension of architecture, a theme Pasolini himself indirectly addressed in his Roman films. The *flâneur*'s varying degrees of attention to what he is reading are conveyed by an inventive use of internal narrative. The inner voice is sometimes loud and clear, sometimes reduced to a mere whisper; occasionally, it even fades completely, leaving only the subtitles. (This technique, which Charles de Meaux had already used in *Marfa Mystery Lights* [2008], involves the viewers in the film by coaxing them to substitute their own inner voices for the absent voice of the narrator.) From shot to shot, the man continues wandering through Rome, until he arrives at the Palazzo Barberini. There, in front of an Artemisia Gentileschi self-portrait—we do not know if it is a chance meeting or a date—he meets a woman, a reader as well, poring over a book of Gentileschi's letters.

This moment of mise en abyme is the key to the film. In her self-portrait, Artemisia Gentileschi has painted herself painting, palette and brush in hand. The work is, therefore, not only a self-portrait but also an allegory of painting. This is when we realize that Charles de Meaux has not made a simple film about two characters who meet in front of a painting but rather an allegory of literature and the seduction of the written word.

Regina Demina (b. 1989) has made a video that draws on the twofold inspiration of Pasolini's poetry and films. *Un vide en chacune de mes intuitions* [A void in each of my thoughts] stages a contemporary Virgin Mary directly modeled on Margherita Caruso's character in *The Gospel According to Matthew*. The video, shot in Puglia like Pasolini's *Gospel*, opens with an apparition: a young woman, pregnant, slowly emerges from the shadows of a hangar—whose curved pediment recalls the stone arch above Pasolini's Virgin Mary—while a male voice-over recites a passage from *Poem in the Shape of a Rose* with phrases removed: "Something is always missing. There's a void in each of my thoughts. And it's vulgar. It's vulgar of me not to be whole. It has never been more vulgar than in this anguish. [...] lost in pure solitary thought, [...] interested in nothing but love..." The reciting continues; the young Madonna walks beneath foliage, falls asleep in a field, then returns home where we see her veiled, serious, pensive. By using the literary technique of "cut-up," and by making images that are timeless but nevertheless anchored in the present day by details (of clothing for instance), Regina Demina revives several Pasolinian themes: the lyricism of nature, the fear of loneliness, shame, sex and love. A reflection of her obsessions, or our own?

Figs. 132, 133 Regina Demina, *Un Vide en Chacune de mes Intuitions* [A Void in Each of my Thoughts], 2023, video, 5', production Nouveau Musée National de Monaco

Figs. 132, 133

Descendants

Salò, an art film for artists

Not surprisingly, *Salò* has inspired contemporary artists more than any other Pasolini film, because it tests the very limits of cinema.

Accordingly, we find one of the versions of the film poster for *Salò* in a work by Giuseppe Stampone that he describes as a "mise-en-scène of the tragedy of society." Just as Pasolini decorated the Villa Aldini's walls with Modernist paintings, Stampone, in this particularly masterful black ball-point pen drawing, places within a mid-seventeenth-century Dutch interior several images: a photograph of Pasolini's corpse; a painting after Masaccio's famous fresco *The Expulsion from the Garden of Eden*; and the *Salò* poster. (The setting itself is copied from Pieter de Hooch's *At the Linen Closet*, held at the Rijksmuseum in Amsterdam.) The anachronistic aspect of the ensemble is accentuated by the simultaneous presence of Pasolini wearing a suit and the little girl from the Pieter de Hooch painting... This rejection of naturalism (the drawing depicts not a real but a mental space) is a means for Stampone to assert the political aim of his work. This coded drawing bears a message: by including in the scene two images derived from opposite approaches to the body (on one side Masaccio, who faithfully painted Adam and Eve shamefully hiding their nudity in accordance with Scripture; on the other side Pasolini, who filmed a naked young man proudly facing his torturers) Stampone implies that the prudishness of Italian society led to Pasolini's death. The drawing therefore implicitly supports the theory—notably expressed by Laura Betti—that Pasolini's murder was commissioned by members of Democrazia Cristiana, a political party close to the Catholic Church.

Fig. 134 Giuseppe Stampone, *Le Mura Domestiche*, 2019, ball-point pen on wood panel, 11½ × 14 in. (29 × 35.5 cm), courtesy of the artist and of the American Academy in Rome

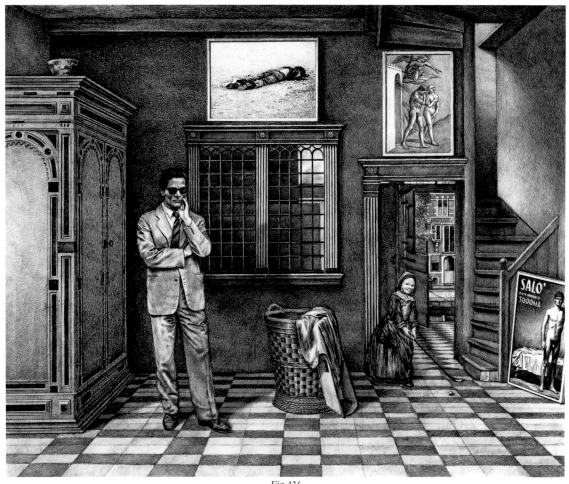

Fig. 134

Descendants

Fig. 135

Fig. 135 Clara Cornu, *1975*, 2023, oil painting on the back of a windshield glass, 45½ × 26 in. (115 × 65.5 cm), artist's collection

The glass-paintings of Clara Cornu (b. 1987) usually depict simple, enigmatic scenes, in which the action is frozen in time, amid a pared-down setting. These scenes evoke games or rituals. It is not surprising, therefore, that of all Pasolini's films, Clara Cornu chose to depict *Salò*. Like Giuseppe Stampone, she approaches the film indirectly, through its décor. As the title of the work suggests (*1975*—the year of the film's release and of Pasolini's murder) the beach on which this theatre stage or filmset has been erected is that of Ostia. We recognize, at the center of the composition, the grand interior staircase of the four Fascists' villa, along with various elements of its furniture: pedestal table, stool, carpet, etc. The atmosphere of Surrealist calm that seems at first glance to reign over the scene is troubled by two details, both taken from the last minutes of *Salò*: a torture instrument made of five long steel claws, and a brazier for working iron up to a white heat. This is the scene of a tragedy, the actors of which have disappeared, perhaps into that netherworld we can glimpse through the red curtains partly opened by a gust of sea wind.

The starting point of *Reunion; Salò* (1998) by the British artist Adam Chodzko (b. 1965) was a flyer he distributed throughout Italy with the caption: "Seeking the children who appeared in the film *Salò* by Pier Paolo Pasolini (1975)." The flyer, which purports to call for a "reunion," contains the miniature portrait of the sixteen teenagers tortured in the film. Such a reunion therefore seems improbable, to say the least, unless it is simply a matter of bringing the actors back into each other's presence twenty-three years after the shooting of the film. We come to understand, however, that Chodzko had an entirely different goal in mind, when we see the series of photographs he made thanks to this flyer: sixteen portraits of the actors who seem not to have aged (needless to say, they are in fact lookalikes) each holding the flyer and pointing to their character. Like Pierre Huyghe before him, Chodzko uncannily interweaves reality and fiction. At once a resurrection and an affirmation of the truth of fiction, *Reunion; Salò* shows that nothing is exactly as it seems—even to the point of vertigo.

Fig. 136

Fig. 137

Fig. 138

Figs. 136, 137, 138, 139 Adam Chodzko, *Reunion; Salò* (details), 1998, installation composed of 5 lithographs (posters), 13 framed C-prints, and a sound video (digitized super 8 film), 20 × 17 × 1½ in. (51 × 43 × 4 cm) (each print), 9' (video), courtesy of the artist and of Galleria Franco Noero, Turin

Fig. 139

Descendants

Pasolini's final film was also the inspiration for an installation by the American conceptual artist Tom Burr (b. 1963): *Salò Chest of Drawers*. The work consists of the piece of furniture named in the title, with two drawers removed. One of them has been leaned up against the wall. At the back of this upright drawer are two publicity flyers for the film (showing the naked victims, the libertine dignitaries, and their assistants) and a heap of sand partly spilled out onto the floor. Burr plays here upon the multiple meanings of the word *chest*: at once furniture and torso. The sand recalls both an hourglass and the line from Genesis, "Thou art dust, and to dust thou shalt return"(3:19), or in other words, the swift passage of time. Here again, one might interpret this enigmatic installation as a *memento mori*. Burr, under that interpretation, reminds his viewers of their mortal nature that can only be redeemed by art. What remains of Pasolini today, aside from a few of his writings and his best films?

Fig. 140

Figs. 140, 141 Tom Burr, *Salò Chest of Drawers (three)*, 2014, installation, found chest of drawers, movie posters, pushpins, plastic sleeves, 19½ × 20 × 46½ in. (49 × 51 × 118 cm) (chest), 6½ × 17½ × 38½ in. (17 × 45 × 98 cm) (drawer), courtesy of the artist and of Galleria Franco Noero, Turin

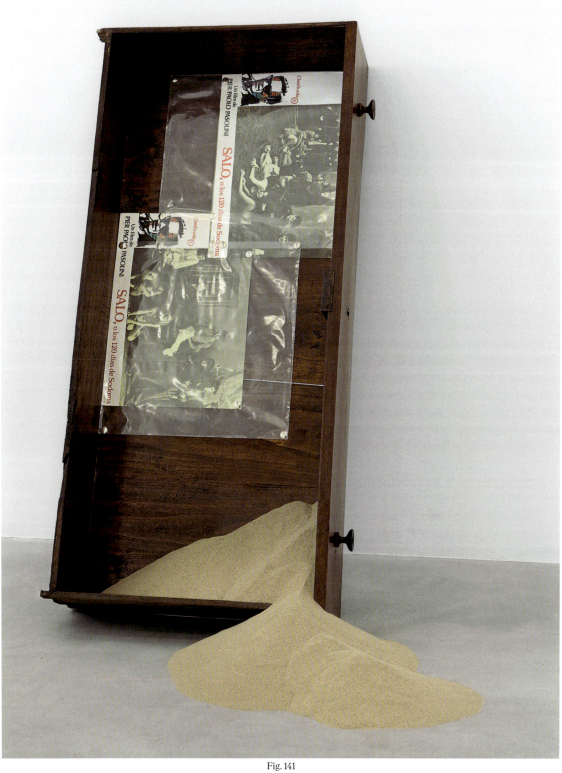

Fig. 141

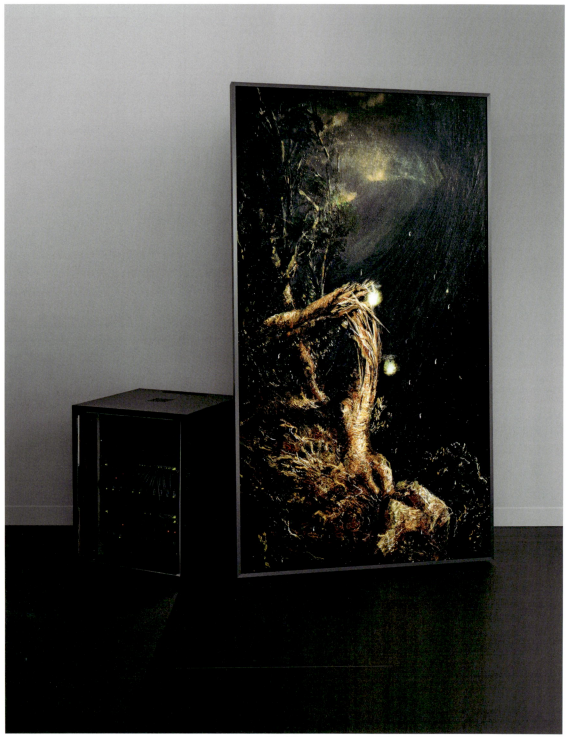

Fig. 142

Fig. 142 Philippe Parreno, *The Blasted Tree, The Fireflies, The Sun and Their Larvae (a Kuramoto Automaton)*, 2023, UHD display screen, server (Raspberry Pi, animation software), 86½ × 49 × 4 in. (219.6 × 125 × 9.7 cm) (screen), 31½ × 23½ × 23½ in. (80 × 60 × 60 cm) (server)

A multitude of echoes

The twenty or so artists mentioned in the previous pages were all directly inspired by Pasolini and his work. Others, just as interesting, could be cited, such as Giulio Paolini (with *Figurino, Teorema*, 1999) or Elisabetta Benassi (with *Alfa Romeo GT veloce, 1975–2007*, 2007). I say this to emphasize that this essay makes no claim to exhaustivity. It would be all the more difficult to do so, since in addition to all the works that explicitly refer to Pasolini's oeuvre, there are at least as many that distantly echo it. The following are two examples of the latter case, drawn from among so many others.

The first is *The Blasted Tree, The Fireflies, The Sun and Their Larvae (a Kuramoto automaton)* by Philippe Parreno (b. 1964). This installation consists of a computer and a screen that plays an animated film. The animated images are of fireflies flashing in undergrowth copied from an oil painting by Jasper Francis Cropsey, *Blasted Tree* (1850). Controlled by the computer that applies a complex mathematical model, the 3D-animated fireflies flash both on the surface and within the landscape, as if inhabiting the painting. The installation can be interpreted as an allusion to Pasolini's well-known article published in the *Corriere della Sera* on February 1, 1975 (and later collected in *Corsair Writings*), in which he connects the disappearance of fireflies to the effects of widespread industrialization.

Fig. 144

The second is *Untitled (Sermon to the Birds)* by Claire Fontaine. This "collective artist," invented in Paris by Fulvia Carnevale and James Thornhill in 2004, takes its name from the famous brand of French stationary. Generally, the artist Claire Fontaine's work explores the concept of the readymade through a multitude of mediums. In the present case, the piece is a reproduction of a detail from a Giotto fresco of Saint Francis of Assisi preaching to the birds. The proximity to Pasolini is immediately striking, since he drew inspiration from the same fresco cycle in the Basilica of Saint Francis for the film *The Decameron*. Pasolini's *Uccellacci e uccellini* is also inspired by the same episode, as it shows two Franciscan monks that Saint Francis has commanded to spread the gospel to the falcons and sparrows. But Claire Fontaine's work also coincides with Pasolini's on an even deeper level that. By reproducing this detail from Giotto's fresco in the form of a lightbox—like the ones used for advertisements in airports and shopping malls, and with its glass surface cracked like a dropped cellphone screen—Claire Fontaine emphasizes the distance between an authentic world and the one created by our society of mass consumption. All this to demonstrate, in conclusion, that even though Pasolini has left us, echoes still reach us from his "consciousness that does not forgive."

Fig. 143 Claire Fontaine, *Untitled (Sermon to the Birds)*, 2018, lightbox and pearl vinyl digital print, edition 1/3 + 2 AP, 109 × 61½ × 4 in. (277 × 156 × 10 cm), private collection

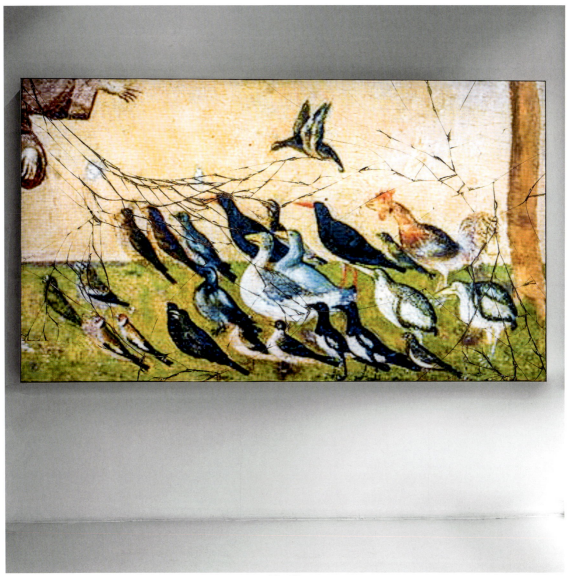

Fig. 143

Descendants

Works Cited

Daniel Arasse, *L'Annonciation italienne. Une histoire de perspective*, Paris: Hazan, 2010

Roland Barthes, *Sade, Fourier, Loyola*, trans. Richard Miller [1976], Berkeley/Los Angeles: University of California Press, 1989

Roland Barthes, *The Pleasure of the Text*, trans. Richard Miller, with a note by Richard Howard, New York: Farrar, Straus & Giroux, 1975

Marco Antonio Bazzocchi, Roberto Chiesi, Gian Luca Farinelli, *Pier Paolo Pasolini. Folgorazioni figurative*, Bologna: Edizioni Cineteca di Bologna, 2022

Simone de Beauvoir, *Must We Burn de Sade?*, trans. Annette Michelson, London: Peter Nevill, 1955

Alberto Brodesco, *Sade au cinéma. Regard, corps et violence*, Aix-en-Provence: Rouge profond, 2020

Luis Buñuel, *My Last Sigh*, trans. Abigail Israel, New York: Vintage, 1984

René de Ceccatty, *Pasolini*, Paris: Gallimard, 2005

René de Ceccatty, *Sur Pier Paolo Pasolini*, Monaco: Éditions du Rocher, 2005

Valérie Da Costa, "Du corps à l'image: montrer / monter l'Histoire selon Fabio Mauri," in *Le Fascisme italien au prisme des arts contemporains*, Luca Acquarelli, Laura Lamurri and Francesco Zucconi (dir.), Rennes: PUR, 2021

Valérie Da Costa, *Fabio Mauri. Le passé en actes*, Dijon: Les presses du réel, 2018

Gilles Deleuze, "The Cold and the Cruel" in *Sacher-Masoch: An Interpretation*, trans. Jean McNeil, London: Faber & Faber, 1971

Ernest Pignon-Ernest, exh. cat., Landerneau, Fonds Hélène & Édouard Leclerc pour la culture, 2022

Giulia Ferracci, Hou Hanru, Bartolomeo Pietromarchi (dir.), *Pier Paolo Pasolini, tutto è santo, il corpo politico*, Milan / Rome: 5Continents / MAXXI, 2022

Alain Fleischer, *Sade scénario*, Paris: Cherche Midi, 2013

Michel Foucault, "Sade, sergent du sexe" [1975], in *Dits et Écrits I. 1954-1975*, Paris: Gallimard, 2001

Les Grands Entretiens d'artpress, Alain Fleischer, Paris: artpress, 2020

Guy Hocquenghem, *La Dérive homosexuelle*, Paris: Delarge, 1977

Hervé Joubert-Laurencin, *Le Grand Chant. Pasolini, poète et cinéaste*, Paris: Macula, 2022

Hervé Joubert-Laurencin, *Pasolini, portrait du poète en cinéaste*, Paris: Cahiers du cinéma, 1995

Michel Leiris, *Journal (1922-1989)*, edition by Jean Jamin, Paris: Gallimard, 2021 [1992]

Curzio Malaparte, *The Kremlin Ball*, trans. Jenny McPhee, New York, New York: New York Review Books, 2018

Éric Marty, *Pourquoi le XXᵉ siècle a-t-il pris Sade au sérieux?*, Paris: Seuil, 2011

Pier Paolo Pasolini, *Écrits corsaires (Corsair Writings)*, trans. Philippe Guilhon, Paris: Flammarion, 2018

Pier Paolo Pasolini, *Lutheran Letters*, trans. Stuart Hood, London: Carcanet, 1983

Pier Paolo Pasolini, *Petrolio*, trans. Anne Goldstein, New York: Pantheon Books, 1997

Pier Paolo Pasolini, *Poésie en forme de rose* (Poem in the Shape of a Rose), trans. René de Ceccatty, Paris: Payot & Rivages, 2015

Pier Paolo Pasolini, *Theorem*, trans. Stuart Hood, New York: New York Review Books, 2023

Pier Paolo Pasolini, *The Selected Poetry of Pier Paolo Pasolini*, ed. and trans. Stephen Sartarelli, Chicago: University of Chicago Press, 2014

Octavio Paz, *An Erotic Beyond: Sade*, trans. Eliot Weinberger, New York: Harcourt Brace, 1998

Marcelin Pleynet, *Art et Littérature*, Paris: Seuil, 1977

Mario Praz, *The Romantic Agony*, trans. Angus Davidson, London: Oxford University Press, 1954 [1933]

Philippe Sollers, *Venice: An Illustrated Miscellany*, trans. Jean-Claude Simoën, Paris: Plon, 2015

Chantal Thomas, *Sade, la dissertation et l'orgie*, Paris: Payot & Rivages, 2002

Frank Vande Veire, *Prenez et mangez, ceci est votre corps*, trans. Daniel Cunin, Bruxelles: La Lettre volée, 2007

Amos Vogel, *Film as a Subversive Art*, London: C.T. Editions, 2005 [1974]

Pasolini: The Art Surrounding His Death and His Body

Bartolomeo Pietromarchi

On May 31, 1975 at the Galleria d'Arte Moderna in Bologna, Fabio Mauri projected *The Gospel According to St. Matthew* onto Pier Paolo Pasolini's torso. Sitting motionless in front of the audience, dressed in a white shirt and with his face only barely illuminated, the director had agreed to be subjected to a kind of cathartic ritual, a sort of public ostension: the screening of a film onto its "auteur." The soundtrack was played at an intentionally high volume, and the light from the projector shone directly into the filmmaker's eyes, blinding him. By reversing the roles of spectator and director, the performance,

Fig. 73 entitled *Intellettuale* [Intellectual], "is therefore a hermeneutic display of Pasolini's work, transposed onto a unique conversational level, in which the linguistic dissection of the mechanism of representation is implemented in parallel with a presentation of the 'ecstatic' and performative nature of his body."[1]

As the first artistic homage to Pasolini's work, this performance transformed the person into a monument, into a living sculpture; it was an "x-ray of the spirit"—of the intellectual subjectivity of the artist and of his conscience, to use Mauri's terms—while at the same time glorifying his body, his physical and symbolic nature. By chance or in some premonitory way, this performance was held the year of Pasolini's death, an event that provoked, in Italy and around the world, a trauma that has not yet been worked through, if we are to judge by the critical, narrative, cinematic and visual works that have been created over the past fifty years with Pasolini as the subject.

Barely two months earlier, on April 8, Mauri had presented another version of the same performance in Rome, as part of a much wider project—a series of related actions and installations bearing a title loaded with political memory and innuendo, *Oscuramento* [Obscuring]. It was designed to be a three-stage journey, with three "stops," as it were, that the audience was invited to visit. At the heart of the work lie

1. Stefano Chiodi, "Dalla voce alla presenza. Il corpo del poeta nel tempo dello spettacolo," *La Rivista di Engramma*, no. 181, May 2021, trans. by Emily Ligniti, pp. 363-394.

references to the artistic world of both Mauri and Pasolini and the state of civil rights, starting with their heightened awareness of the political and cultural confines of Italy at the time, which the country had yet to face up to. The historical aspect of the project was moreover confirmed by the three sites that Mauri chose for his works (the Studio d'arte Cannaviello, the Museo delle Cere de la Piazza Santi Apostoli and, not far from there, the studio of photographer Elisabetta Catalano), all located in the vicinity of the Piazza Venezia, Fascism's symbolic heart.

Oscuramento therefore fits into the context of the oppressive atmosphere prevailing in Italy that year, as political and social conflicts were becoming more radical (this was in the midst of the "Years of Lead"), and as a return to the control and limiting of personal freedoms seemed more likely. In May, one month after the performance, the "Legge Reale" law was passed extending police powers of repression and control. In August, Pasolini published in *Il Mondo* an article entitled "Bisognerebbe processare i gerarchi DC" ["Christian Democrat leaders should be put on trial"]: in it he spoke of the Mafia, the CIA, corrupt secret services and the "anthropological mutation" of Italians. History repeats itself. The means become more subtle and sophisticated but the goal remains the same.

Pasolini and Mauri both thought deeply about the misuse of power and the recurring mechanisms of depravity and humiliation of the weak, the cult of violence and death. Themes related not only to the twentieth century's darkest legacy but also to its unexpected return in developed societies, in the black heart of the economy and consumer culture. This was a time when intellectuals were called upon to keep watch for a resurgence in occult forms of totalitarianism, and the threat of a new, even more intrusive "obscuring" than the previous one.

Ostia.

In the first part of the film *Caro diario* [Dear Diary], in a long sequence shot, the camera follows Nanni Moretti as he slowly drives a Vespa along the Ostia seafront. He is looking for the exact spot where Pasolini's dead body was discovered, marked by a small sculpture tucked away on an abandoned dirt football pitch. The film dates from 1993, and the monument is a shadow of what Moretti would have liked it to be; it was poorly designed from the beginning, now in

Fig. 144　Elisabetta Benassi, *Alfa Romeo GT Veloce 1975-2007*, 2007, car (1975 Alfa Romeo GT 2000 Veloce) with the two sidelights, headlights, and main-beam headlamps on, power cables, 59 × 63 × 169½ in. (150 × 160 × 430 cm), UniCredit Art Collection, on loan at MAXXI Museo Nazionale delle Arti del XXI Secolo, Rome

disrepair, and yet, with its air of dilapidation, misery and poverty, it may well have pleased Pasolini.

On this same coastline, in 1978—three years after the poet's tragic death—Nanni Moretti had filmed a scene from *Ecce bombo* in which a rag-and-bone man pushing a trolley cries out—a Pasolini-type appearance. His cry awakens the four friends, including Moretti himself, who had spent the night on the beach talking about their existential crises, of a decade that had lost all its cultural references and sense of political commitment: "But what are we doing? What is happening? When will we see the sun? I don't feel well... And I'm cold..."

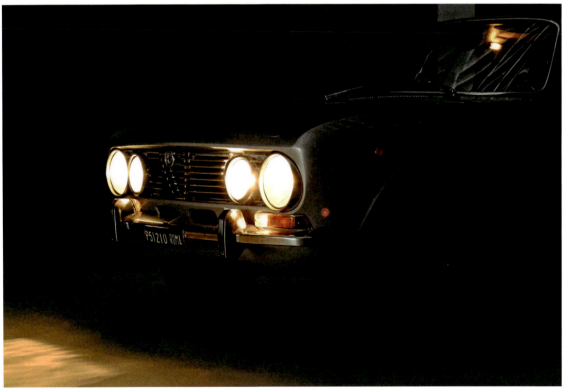

Fig. 144

Pasolini's murder near the Ostia seaplane base was also the subject of an artwork by Elisabetta Benassi, *Alfa Romeo GT Veloce 1975–2007*, comprising a grey vintage Alfa GT coupe, exactly the same as Pasolini's and which became a horrific instrument of torture on the night of his death. It sits, with all its headlights on, in a dark, enclosed space, so that only its outline can be made out. Among the multiple layers of possible interpretations, the artist returns, in this case, to the materiality of the poet's body, confronting the spectator with the last image seen by Pasolini before being crushed by his own car. It becomes a "freeze frame" endowed with all the materiality of a real object but which remains suspended, since that long-ago year of 1975, as if to suggest a temporal void, as Stefano Chiodi wrote about the work, that "defies the accumulation of time through a sort of opinionated passive resistance and obstinacy that is opposed to the darkness in which it is plunged."[2] The relationship between Pasolini and death has also produced a great amount of writing and debate, as for him, "death asserts an instantaneous montage of our lives: in other words, it chooses the truly meaningful moments and puts them in a sequence, transforming an infinite, unstable and uncertain present into a clear, stable, certain and therefore easily describable past."[3] Bernassi's artwork calls to mind the famous photograph that appeared in all the newspapers the day after Pasolini's murder, where his lifeless body lay face down on the ground, covered with dirt and dust. This same image—now iconic—William Kentridge reproduced in monumental dimensions on the banks of the Tiber, as part of his major public art project *Triumphs and Laments* (2016); although his face is hidden, and so in theory he is impossible to identify, Pasolini's corpse is highly recognizable and thus, even in death, a vector of heavy emotional charge. As with Aldo Moro, and his body stuffed into the boot of the Red Brigades' Renault 4L or that of Che Guevara lying on a small bed, Pasolini has been transformed, in the collective imagination, into the icon of a contemporary martyr. This same image was used in one of Giuseppe Stampone's artworks, where Pasolini was "inserted" into a bourgeois and domestic interior scene from a seventeenth-century painting by Pieter De Hooch. Acting as a kind of rebus puzzle, this drawing recreates the filmmaker's contradictory and enigmatic nature, morals and ethics,

Fig. 108

Fig. 134

2. Stefano Chiodi, "La discordanza inclusa. Arte e politica dell'arte," in Gabriele Guercio, Anna Maria Mattirolo (eds.), *Il confine evanescente. Arte italiana 1960-2010* (Milan: Mondadori-Electa, 2010), pp. 157-95.
3. Pier Paolo Pasolini, "Observations on the Sequence Shot," in *Heretical Empiricism*, trans. by Ben Lawton and Louise K. Barnett (Washington: New Academia, 2005), pp. 236-37.

Fig. 145 Marzia Migliora, *Pier Paolo Pasolini,* 2009, mural installation made up of letters in polished stainless steel, edition of 3; height: 6 in. (15 cm); length, left wall: 8 ft. 11 in. (2.72 m); length, right wall: 17 ft. (5.19 m)

Fig. 145

and his well-meaning yet hypocritical spirit, through the images of Adam and Eve cast out of Paradise, and through the feminist slogans and castrative gestures of a man who, having gone from Sodom to Gomorrah, amputated and depoliticized, has been reduced to the state of a simple body, naked or perhaps dead.

At around the same time (2014), Abel Ferrara's film *Pasolini* recounts the final hours of "PPP"'s life, blending reality and onirism, and premonitions and scenes based loosely on his final novel *Petrol*, unfinished and published posthumously in 1992. Seen as a prophetic work on power, as the chronicle of an initiatory voyage or a non-fiction novel on the death of Enrico Mattei, this book was, as the author confided in a letter to Alberto Moravia, "the preface to a testament, an account of the little knowledge we have accumulated." During those last months, Pasolini was finishing the filming of *Salò, or the 120 Days of Sodom*: by transposing the story of the Marquis de Sade into the dark and violent Italian context of the civil war and the resistance, the film transforms an account of history into a metaphor for the human condition, seen in all its more repugnant and contradictory aspects, which Abel Ferrara in turn evokes through his scene of an initiatory rite on the beach.

Fig. 127

While alive and even after his death, Pasolini knew how to place at the heart of his work and thoughts the primordial nature of the body, its biopolitical value in social mechanisms and, therefore, in the processes of construction and reconstruction of identities. Because, since the Holocaust, this is the theme around which the negotiation of the identity of the modern subject has played out; it has proven to be and remains crucial in the cultural reflections made after this event. Pasolini had sensed that this negotiation of personal identity takes place through the redefinition of the body, and that what is accepted or rejected would become the turning point for future battles for civil rights, whose stakes would be the emancipation of humankind from authoritarian and normative powers, with self-affirmation in all its forms being the result. Underlying Pasolini's creations and thought, we find the concept of "corporeal anomaly," understood in its largest sense to include both biological sex and the presentation of the self in accordance with modes that disagree with pre-established codes—including, therefore, sexual (gender and orientation) and sentimental modes—

and going beyond any notion of "deviance" and by extension, sin, crime or illness.

Pasolini thus raised, with the combined force of poetry and scandal, the question of homosexuality and gender, with regard to the origin of biological life; he denounced "anthropological mutation," prevarication, violence, marginalization and racism, thus laying down the foundation for the long process of deconstructing subjectivity and its political negotiations, amplified today by the virtual dimension of social networks, in which we can witness the reinvention and continual increase in identities and genders according to a fluid process, one that is constantly evolving, and that eludes set categories and restrictive definitions. After a long gestation period and after a process of reflection on gender studies in particular, our attention has finally turned towards the need for a different type of inclusiveness, one that is more aware and that has more freedom.

From Fabio Mauri, in 1975, up until today, this has been the starting point for many artists in their reinterpretation of the relevance and urgency of Pasolini's message. And it is his grand vision, in the form of a final warning, that Marzia Migliora reproduced in gigantic, shiny, metallic letters in her artwork *Pier Paolo Pasolini 2009*, a sentence from his famous last interview with poet Furio Colombo, the very day he died: "Maybe I am wrong, but I will continue to say that we are all in danger."